THE BEST OF WATERCOLOR

VOLUME 3

First published in the United States of America
by Quarry Books, an imprint of
Rockport Publishers, Inc.
33 Commercial Street
Gloucester, Massachusetts 01930-5089
Telephone: (978) 282-9590
Facsimile: (978) 283-2742

Distributed to the book trade and art trade in the United States by
North Light Books, an imprint of
F & W Publications
1507 Dana Avenue
Cincinnati, Ohio 45207
Telephone: (800) 289-0963

Other distribution by
Rockport Publishers, Inc.
Gloucester, Massachusetts 01930-5089

ISBN 1-56496-615-1
10 9 8 7 6 5 4 3 2 1

Design: Sawyer Design Associates, Inc.
Diane Sawyer, Nina Souther
Cover Image:
 Moonlight and Fruit, Judy Bates, see page 122.
 Pair of Pears, Terry Wickart, see page 120.
 Rose Althea II, Jay Rather, see page 58.

Printed in China.

THE BEST OF

WATERCOLOR

VOLUME 3

GLOUCESTER MASSACHUSETTS

QUARRY BOOKS

INTRODUCTION

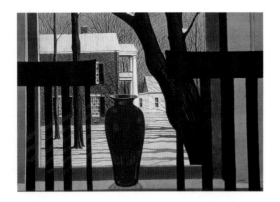

ROLLAND GOLDEN
Lexington Views II

(*see page 84*)

Watercolor is often thought to be an easy medium. It is not. Tricky, but also very flexible, it gives artists the opportunity to use it in a variety of ways—from transparent wet-in-wet washes to tight renderings, from bold brush strokes to dry brush.

This flexibility encourages them to work in different modes of expression. Jurors looking at slides see realism, impressionism, hard-edge abstraction, symbolism, and all kinds of in-between trends artists choose to follow.

It is a joy for the juror to see a multitude of temperaments and visions, to discover what attracts this particular artist, what he or she considers beautiful and meaningful. Judging slides is, in other words, an enriching experience. There are, however, painful moments.

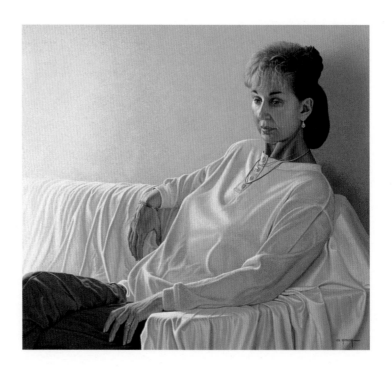

JOE MANNING
The Light of My Life

(*see page 136*)

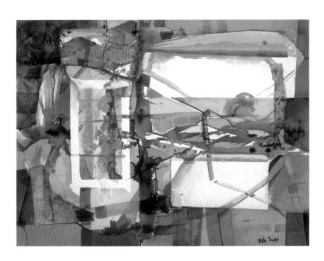

BABS SCOTT
Going Through
(*see page 81*)

In all competitions, jurors must select a limited number of works from a much larger group of submitted slides. Accepting outstanding works and declining obviously less accomplished ones is easy. But what about a large number of good-quality paintings that seem to have equal artistic merit? Only a small part of them can be accepted, and a distasteful process of trimming down sets in. Many times, jurors try to convince themselves that one painting has something that the other has not. But is it true? No wonder an artist whose work was rejected asks: "Why me? The painting that was accepted is so similar to mine!"

That may be one of the reasons. Paintings of similar subject matter, popular styles and techniques, but without a touch of personal vision, may cancel each other out. Fortunately, good experienced artists know these pitfalls and try to avoid them in competitions.

My good friend and colleague, Betty Lou Schlemm, a wonderful watercolorist, has invited me to be her co-juror, and I want to thank her for her understanding and insights. We selected works of various styles and techniques to show the range of watercolor painting, hoping that this book will be an inspiration to its viewers and readers.

—Serge Hollerbach, AWS, NA

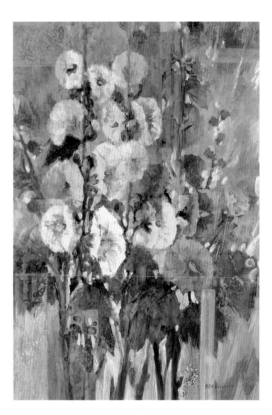

WOLODIMIRA VERA WASIEZKO
Showy Moment
(*see page 69*)

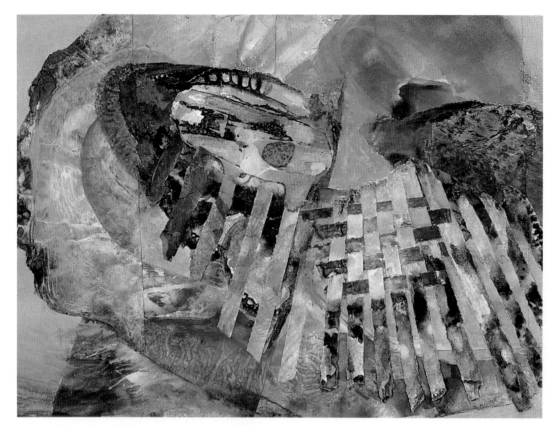

MARGARET C. MANTER
Life Cycle

22" × 30" (56 cm × 76 cm)
Arches 140 lb.
Watercolor, ink, and acrylic

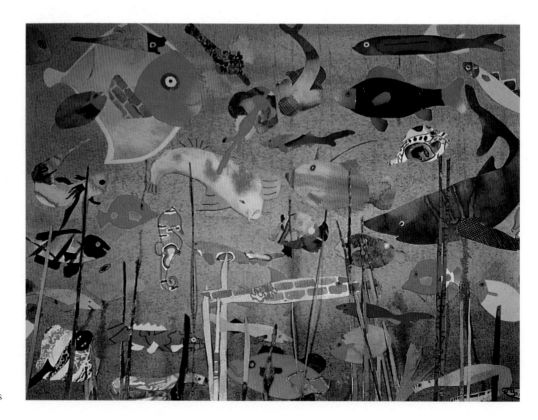

FRAN FOY
Fish Fiddle De-Dee

24" × 30" (61 cm × 76 cm)
Fabriano 90 lb. cold press
Watercolor, base, and cut-outs

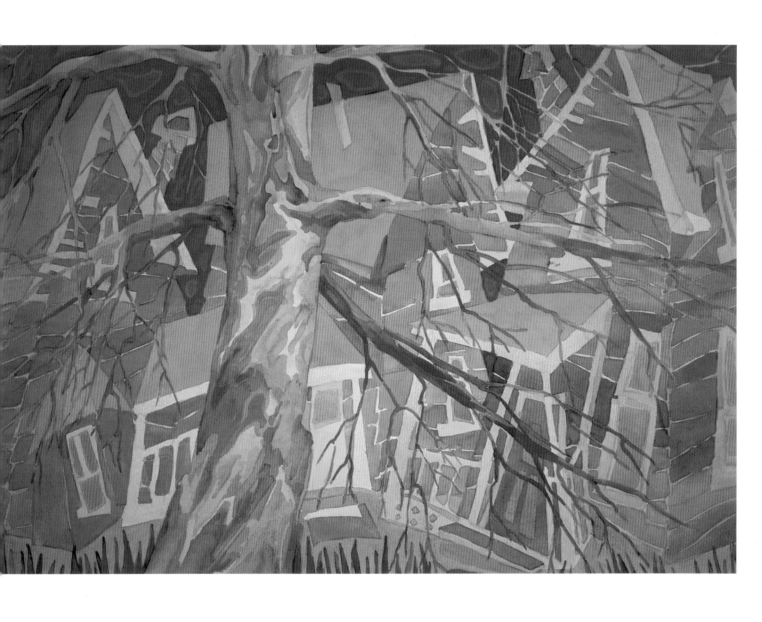

SUSAN WEBB TREGAY
Sycamore Street

22" × 30" (56 cm × 76 cm)
Arches 140 lb. cold press

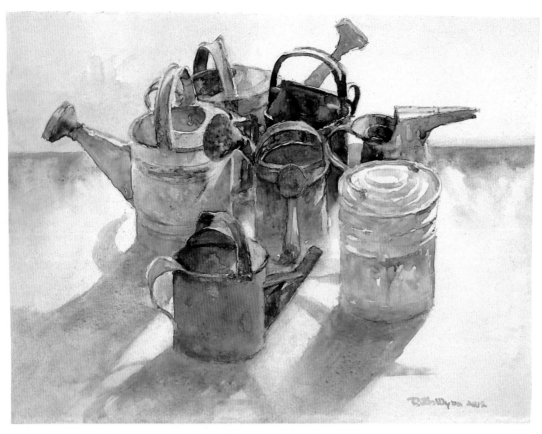

RUTH F. WYNN
Gathering for Gardeners

15" × 20" (38 cm × 51 cm)
Plate Strathmore illustration
board

RHODA YANOW
The Shawl

28" × 20" (71 cm × 51 cm)
Strathmore bristol board
500 lb. ply plate surface
(opposite)

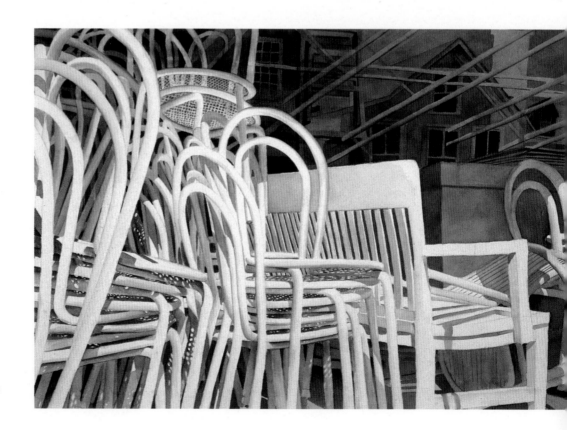

ANDREW R. KUSMIN
Summer's on Vacation

22" × 30" (56 cm × 76 cm)
300 lb.

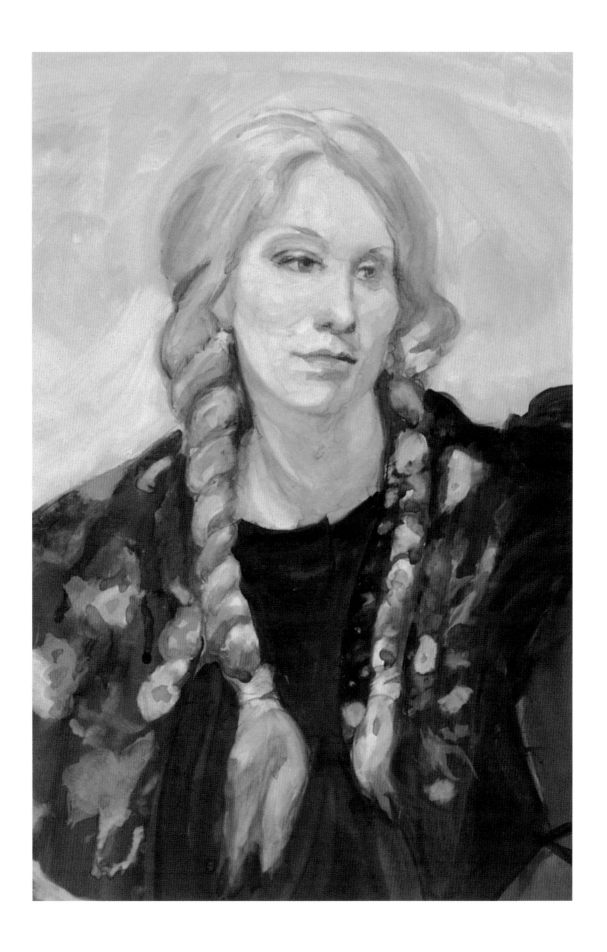

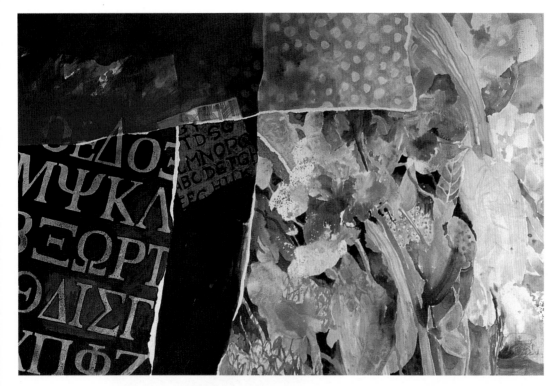

DOROTHY S. GANEK
Montage

26" × 40" (66 cm × 102 cm)
Arches 260 lb. hot press
Watercolor and acrylic

PHYLLIS HELLIER
Doors to Decision

30" × 22" (76 cm × 56 cm)
Arches 300 lb. cold press
Watercolor, gouache, and ink
(opposite)

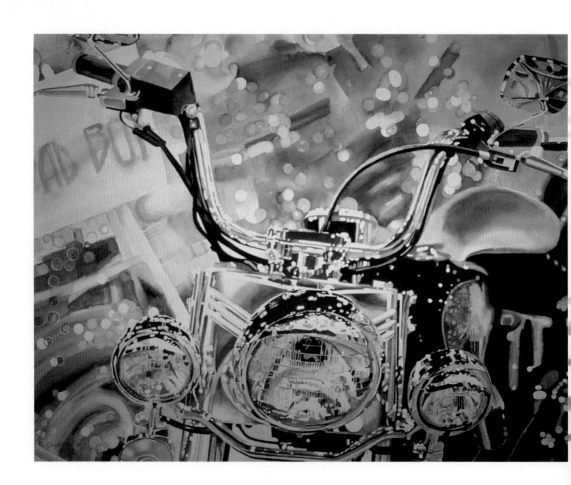

RUTH COCKLIN
Bad Boy

29" × 38" (74 cm × 97 cm)
Arches 280 lb. cold press

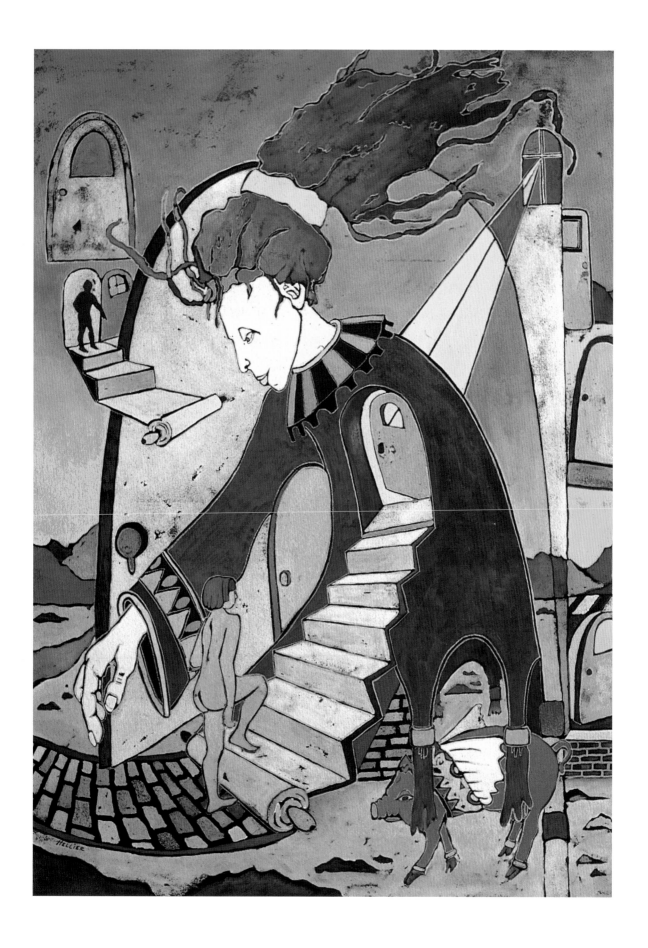

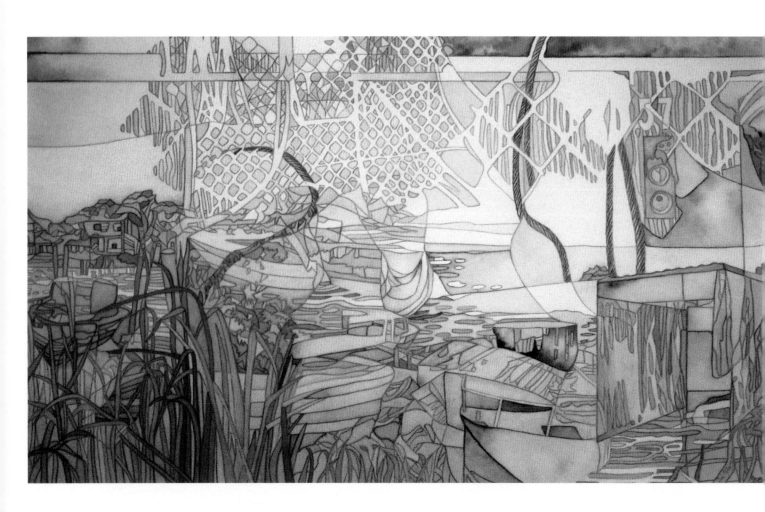

Robert DiMarzo

Fordson Island I

17" × 20.5" (43 cm × 52 cm)
Smooth 100% rag 140 lb.
cold press

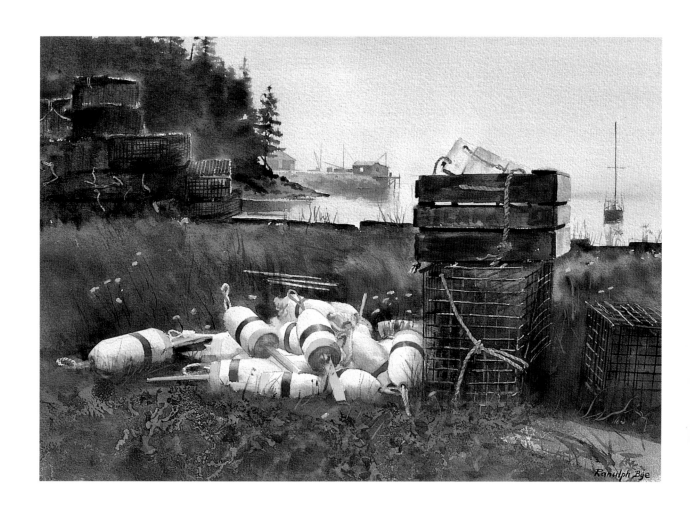

RANULPH BYE

Lobsterman's Still Life

18" × 25" (46 cm × 64 cm)
Arches 300 lb. cold press

AL BROUILLETTE
Passages 28

28" × 19" (71 cm × 48 cm)
Fabriano 140 lb.
Watercolor and acrylic

CONNIE GLOWACKI
Autumn Path

15" × 11" (38 cm × 28 cm)
Winsor & Newton Press
Arches rough 300 lb.
(opposite)

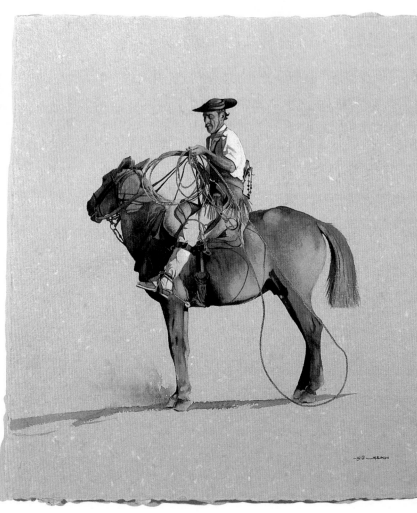

J. MARK KOHLER
Rojas

16" × 16" (41 cm × 41 cm)
St. Armand handmade 555 lb. rough
Watercolor and white gouache

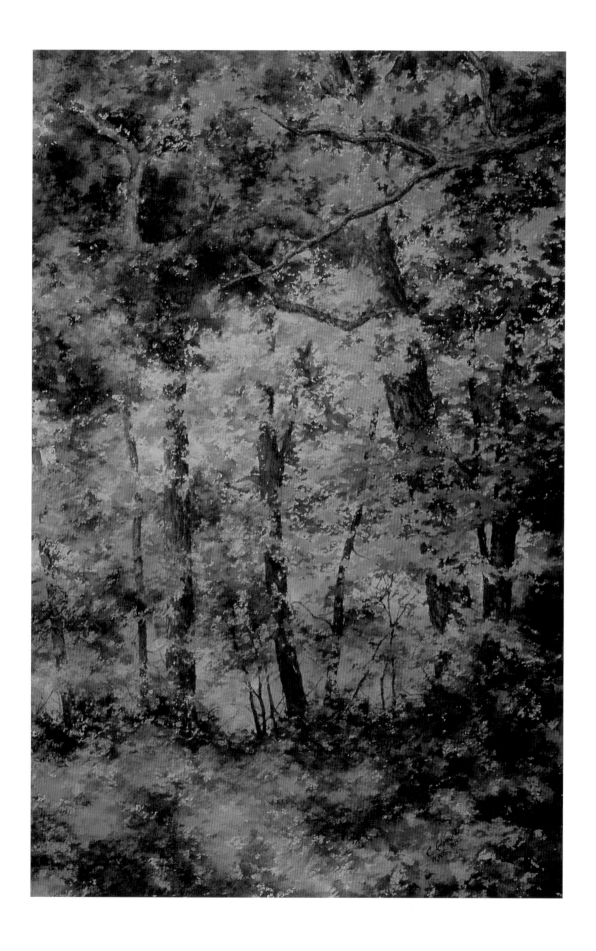

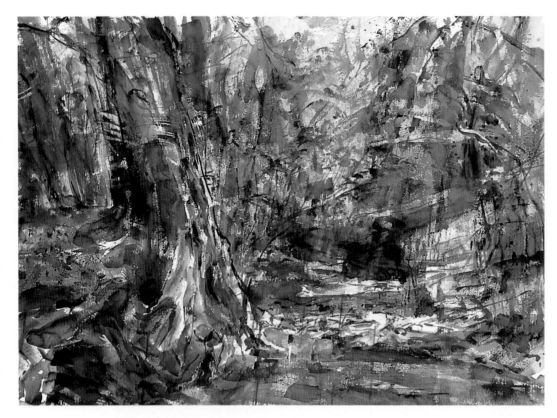

ALEX McKIBBIN
Environs of Pamajera
29" × 40" (74 cm × 102 cm)
Arches 550 lb.

FRANK FEDERICO
Hollywood USA
29" × 22" (74 cm × 56 cm)
Arches 140 lb. cold press
(opposite)

DORTHE M. CHILCUTT
Claudette's Hat
30" × 36" (76 cm × 91 cm)
Arches 140 lb. cold press

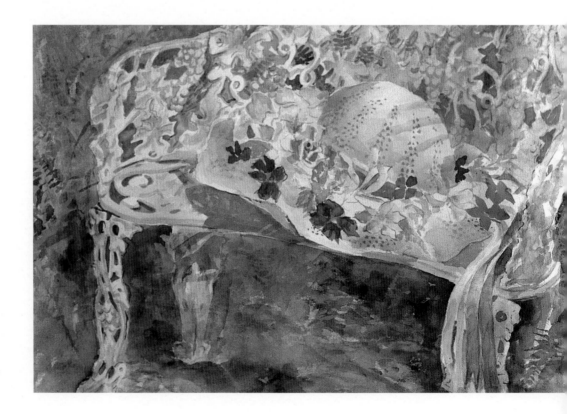

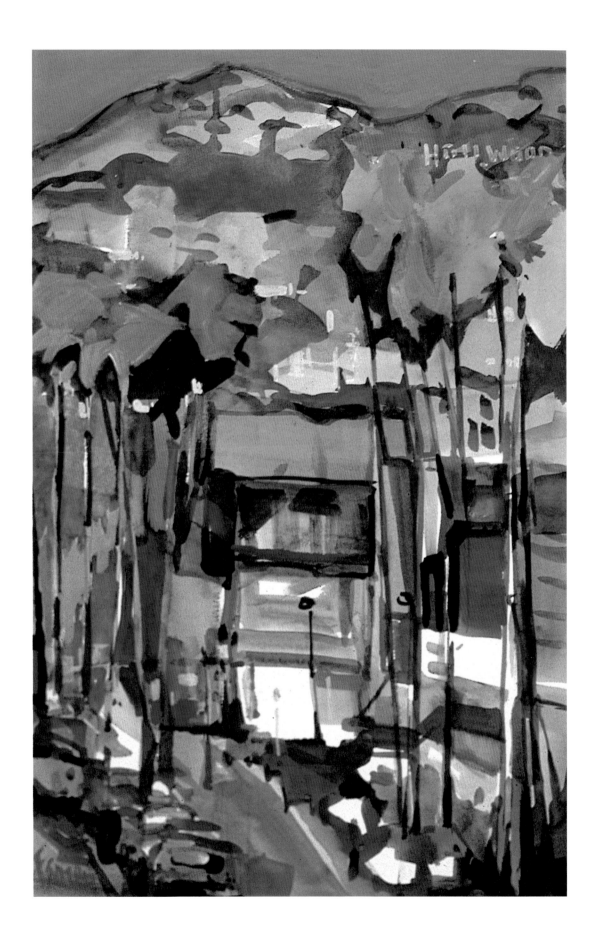

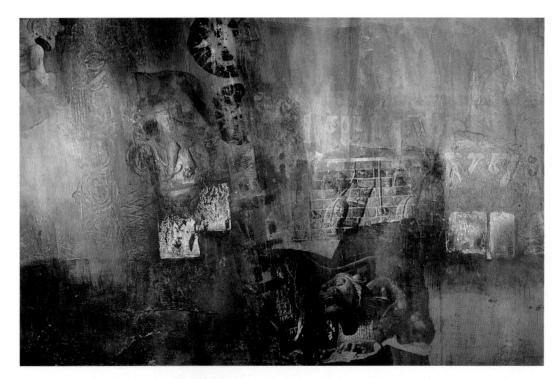

BETTY CARMELL
SAVENOR
Ancient History

20" × 30" (51 cm × 76 cm)
Strathmore illustration board
140 lb.

MORRIS MEYER
Sun Kissed

28" × 20" (71 cm × 51 cm)
Arches 350 lb.
(opposite)

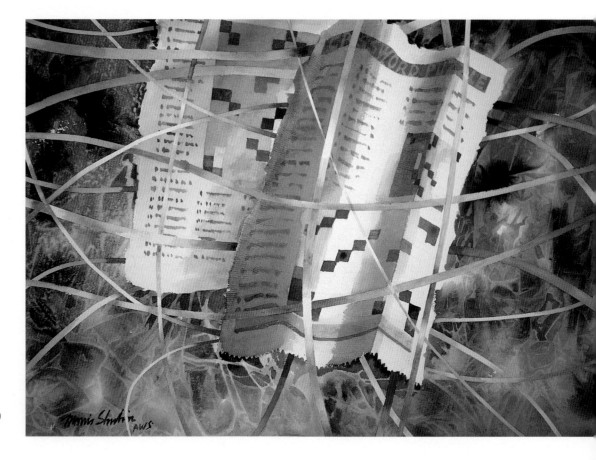

MORRIS SHUBIN
Ticker Tape

22" × 30" (56 cm × 76 cm)
Arches 300 lb.

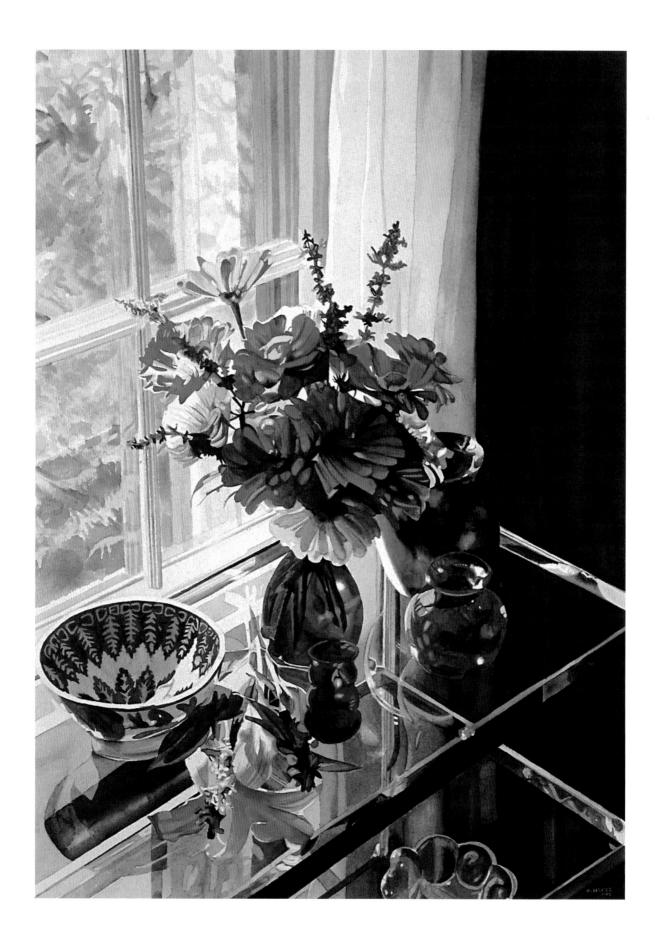

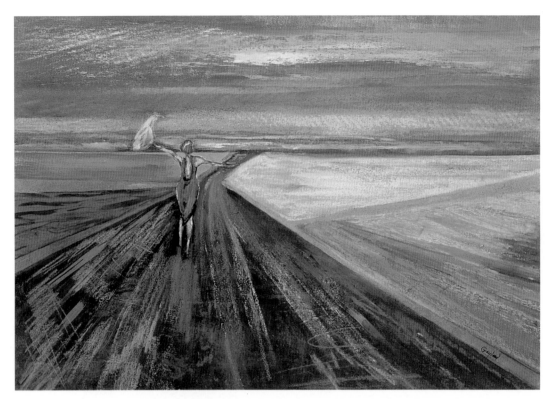

DEE GAYLORD
Goodbye Nebraska—Hello Florida

22" × 30" (56 cm × 76 cm)
Arches 180 lb.
Watercolor and acrylic

LEONA SHERWOOD
Gurbio, France

18" × 15" (46 cm × 38 cm)
Arches 140 lb. cold press
Watercolor and collage
(opposite)

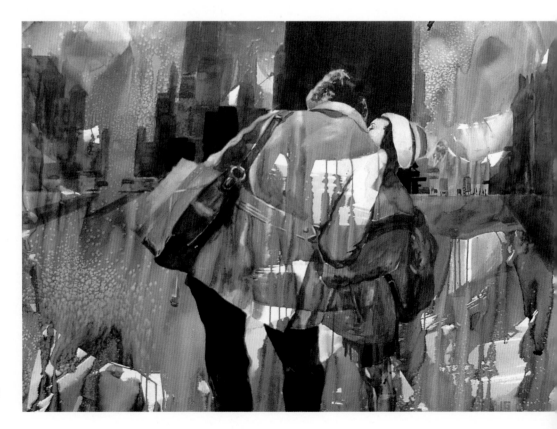

GUY F. LIPSCOMB
Sky Rockets G

30" × 48" (102 cm × 122 cm)
cold press paper

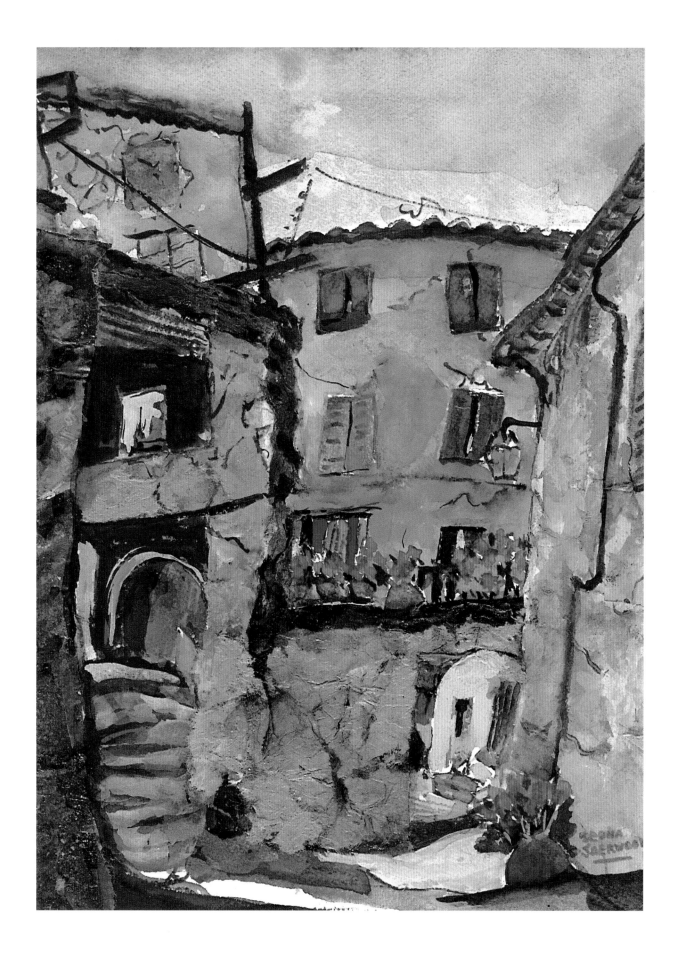

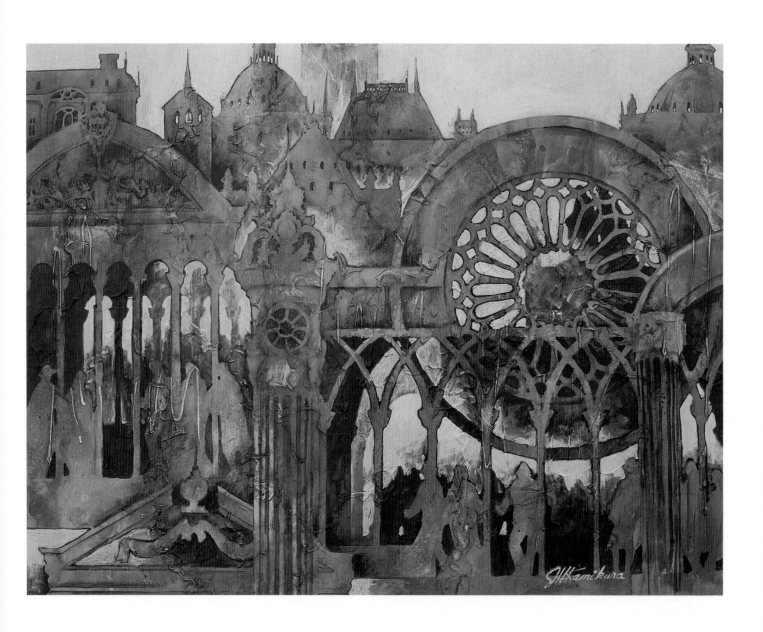

JOYCE H. KAMIKURA

Ambience

24" × 30" (61 cm × 76 cm)
Board
Watercolor and acrylic

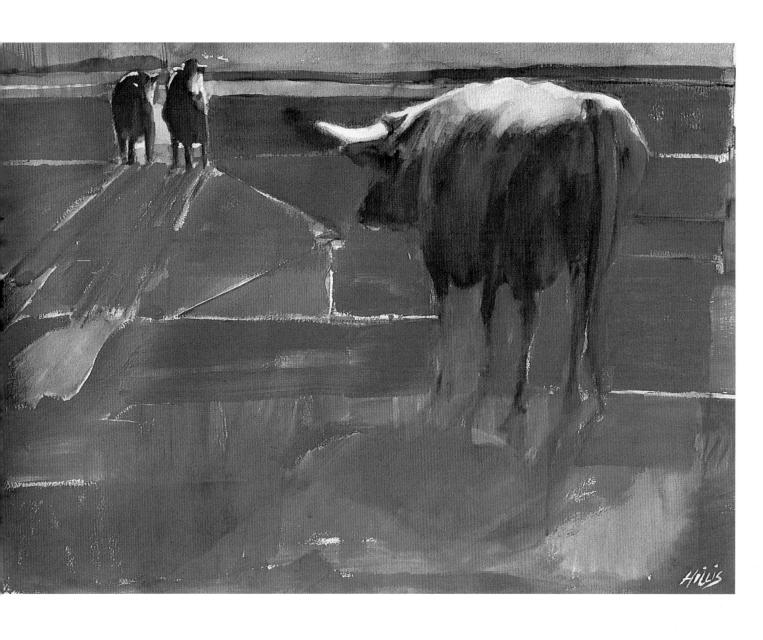

RICHARD K. HILLIS
Breeding Stock
29" × 41" (74 cm × 104 cm)
Arches 300 lb.
Watercolor and water-based
paint

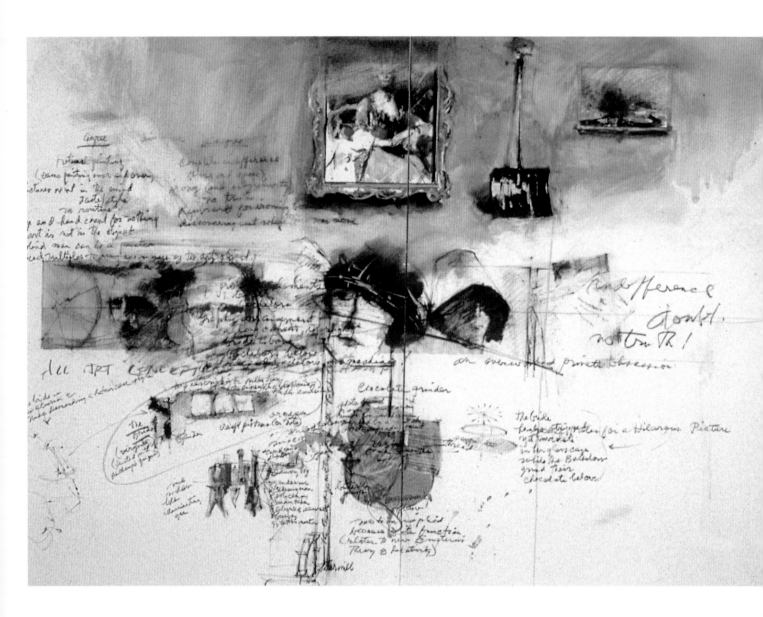

ALEX POWERS

Marcel Duchamp I

40" × 62" (102 cm × 157 cm)
Strathmore illustration board
Watercolor, gouache, charcoal,
and pastel

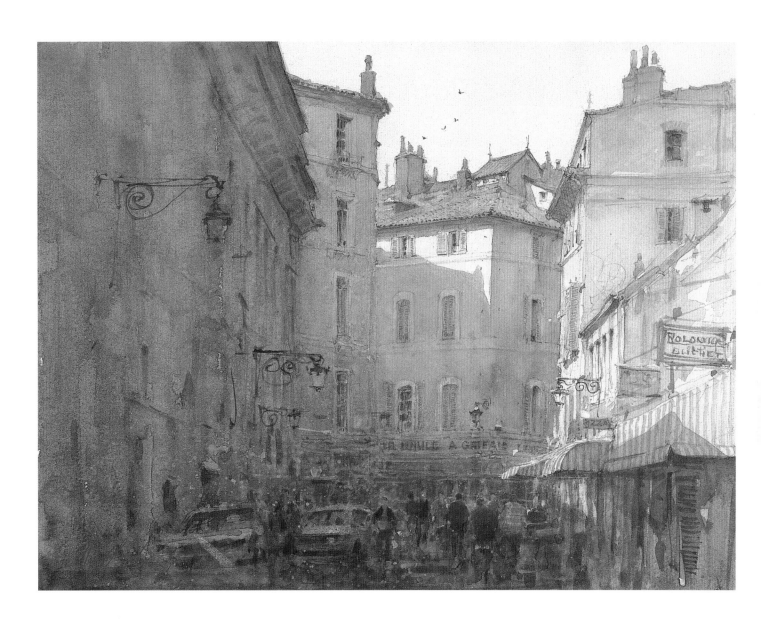

JOSEPH ZBUKVIC
Afternoon Shade, AIX
13.75" × 10.25"
(35 cm × 26 cm)
Saunders 300 gsm rough
Watercolor and Pelikan white
for highlights

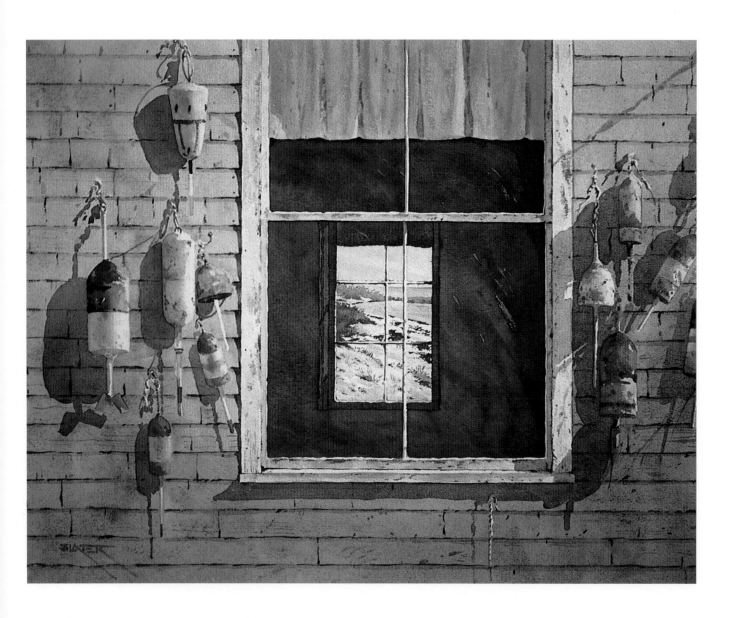

JESS SLATER
Cape Cod

20" × 27" (51 cm × 69 cm)
Lanaquarelle 140 lb. rough

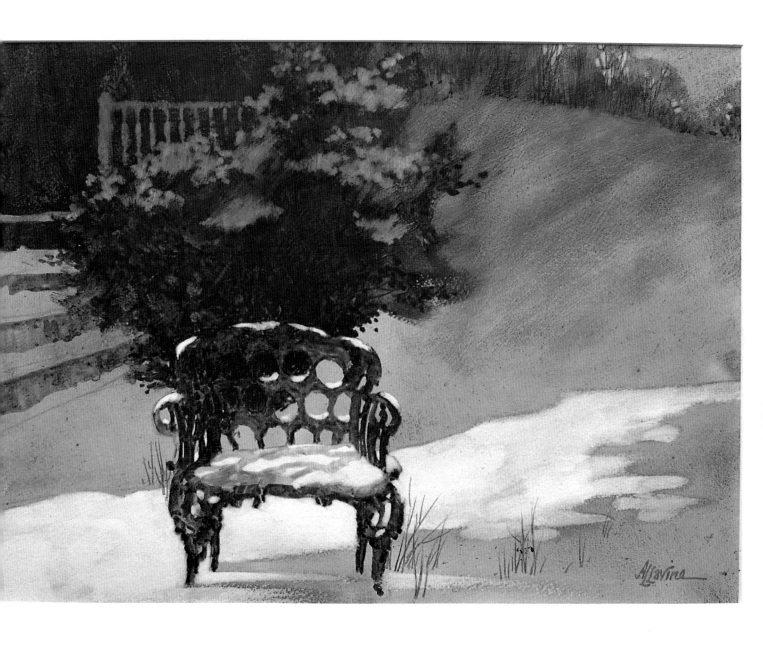

ALEXIS LAVINE
Waiting for Spring

11" × 15" (28 cm × 38 cm)
140 lb. watercolor paper with
two coats of acrylic gesso

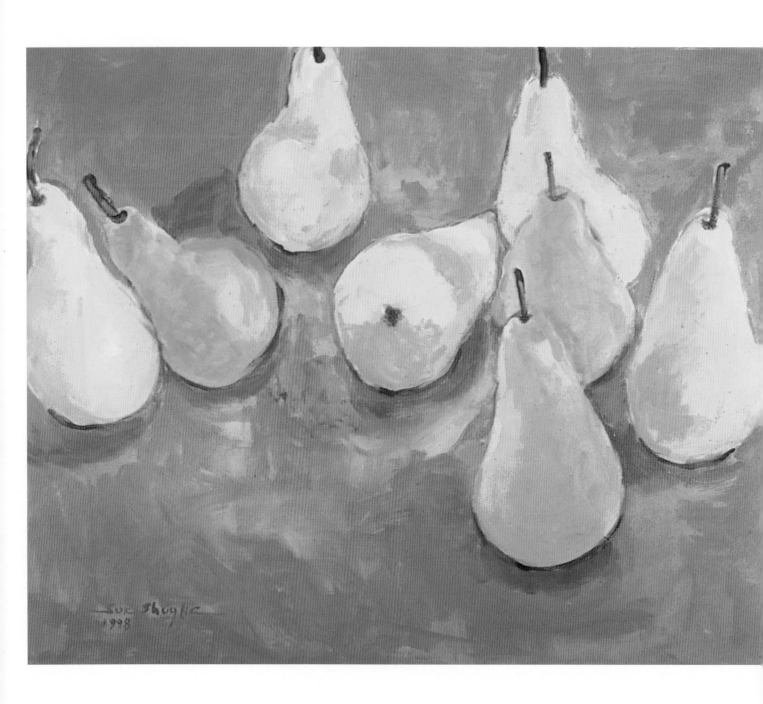

SUK SHUGLIE
Pears
24" × 30" (61 cm × 76 cm)
Canvas
Watercolor and acrylic

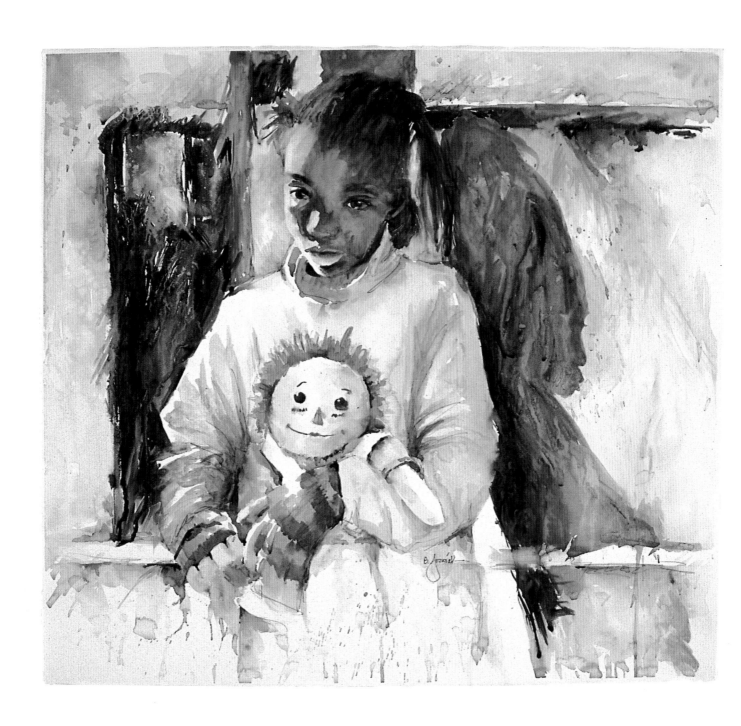

BEV JOZWIAK
Best of Friends

22" × 24" (56 cm × 61 cm)
Lanaquarelle 140 lb. hot press
Watercolor and gesso

D. GLORIA DEVEREAUX
Emergence

22" × 30" (56 cm × 76 cm)
Arches 300 lb. cold press
Watercolor and acrylic

PAT FORTUNATO
Psychedelic Silk 2

36" × 30" (91 cm × 76 cm)
Waterford 200 lb.
(opposite)

GREGORY LITINSKY
November Still Life

22" × 30" (56 cm × 76 cm)
Arches 140 lb. cold press

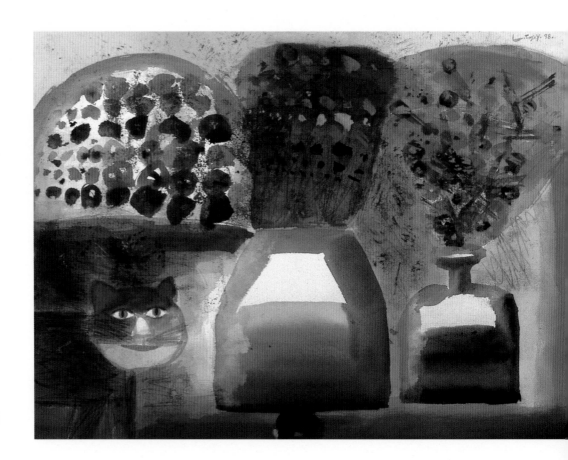

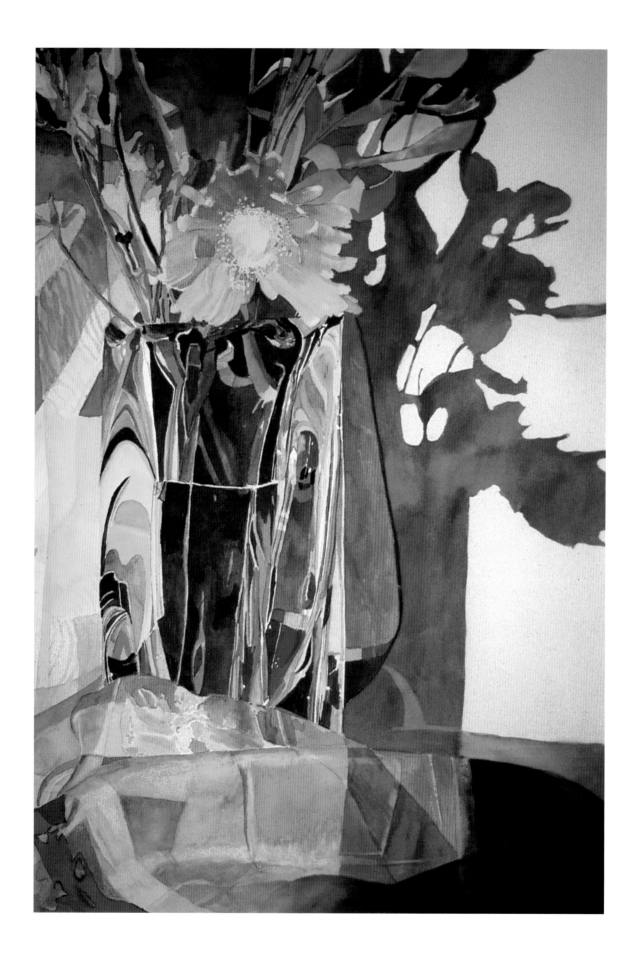

DORLA DEAN SLIDER
School Zone

17.5" × 24.5" (44 cm × 62 cm)
Gessoed illustration board
Watercolor and acrylic

ROBERT L. BARNUM
Street Rhythms

26" × 20" (66 cm × 51 cm)
Arches 300 lb. cold press
(opposite)

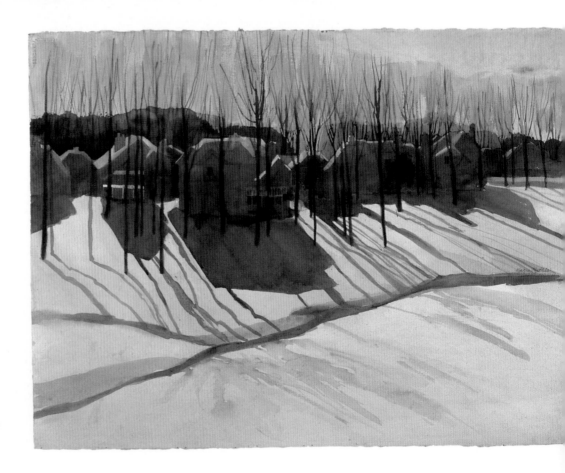

KAREN MATHIS
Winter Light

22" × 30" (56 cm × 76 cm)
Arches 140 lb. cold press

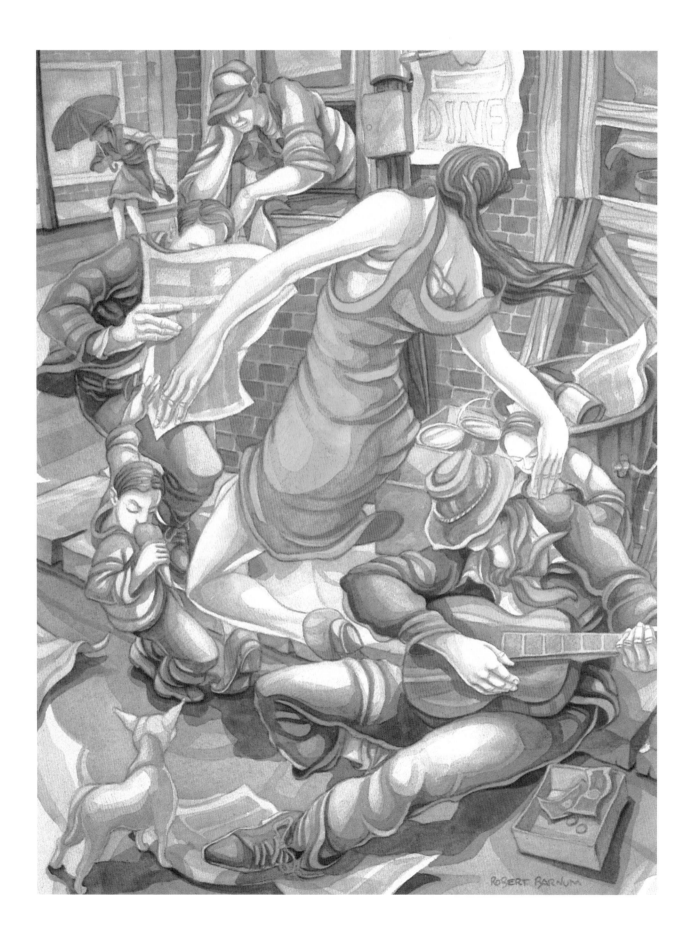

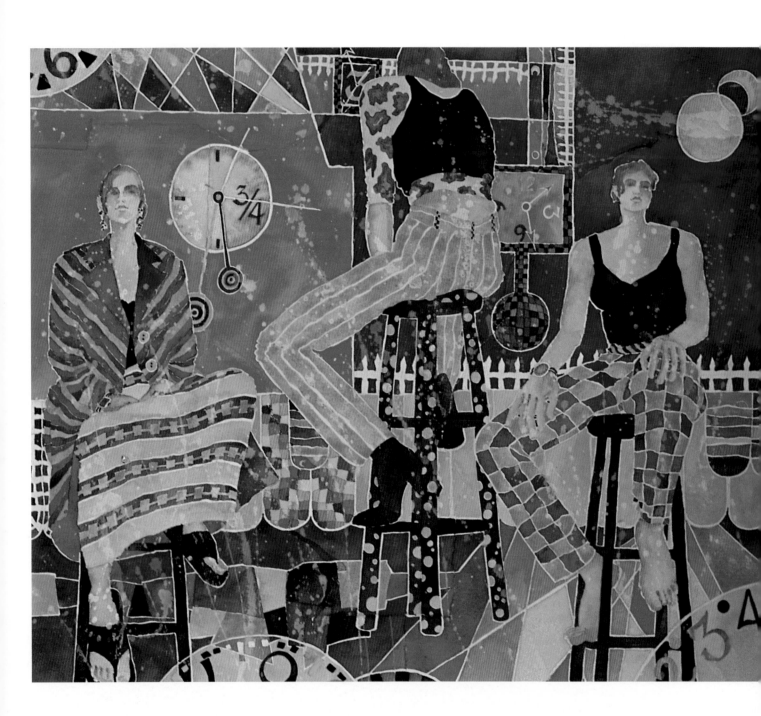

Barbara A. St. Denis
Time Series 26: The Audition
25.75" × 30" (66 cm × 76 cm)
Arches 140 lb.

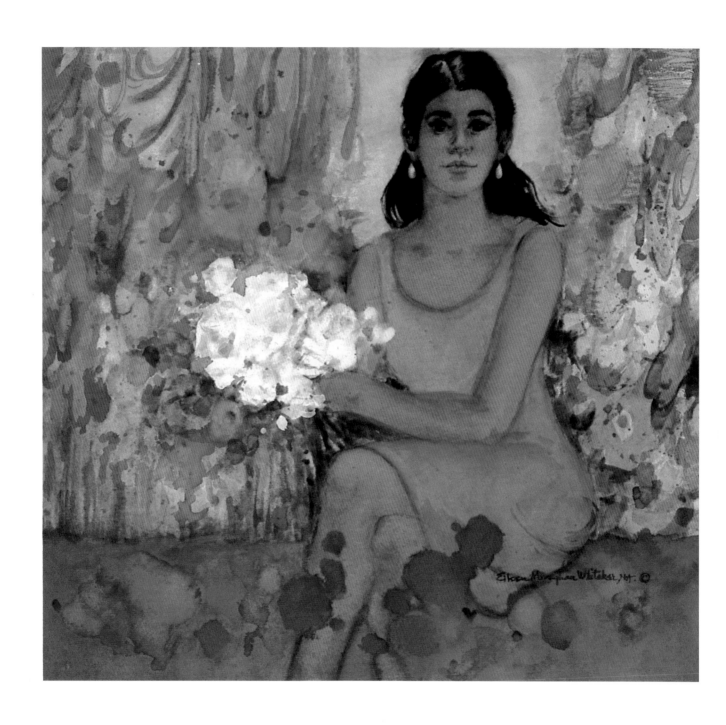

EILEEN MONAGHAN WHITAKER
The Girl in the Red Dress
22.5" × 24.5" (57 cm × 62 cm)
Watercolor paper 300 lb.

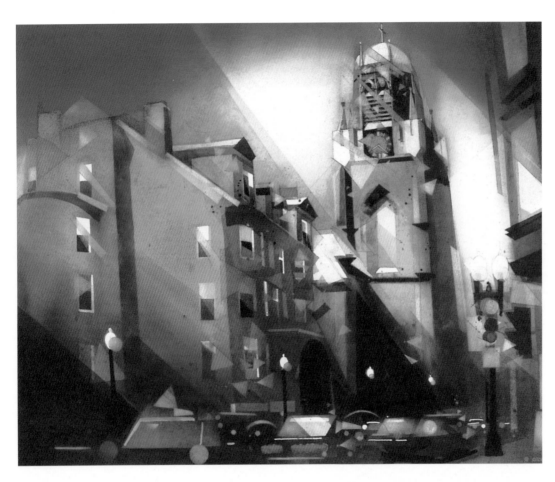

DONALD STOLTENBERG
South Boston Streetscape

21.5" × 28.5" (55 cm × 72 cm)
Arches 140 lb. cold press
Watercolor and Chinese white

ANITA MEYNIG
Fashion

30" × 22" (76 cm × 56 cm)
Fabriano 140 lb.
(opposite)

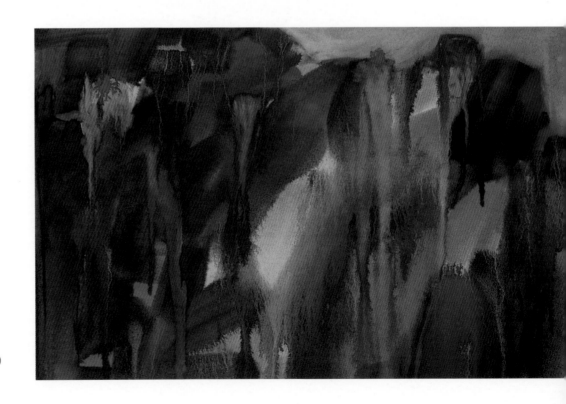

ALINE BARKER
Hemlock Cliffs

22" × 15" (56 cm × 38 cm)
Arches 140 lb. cold press

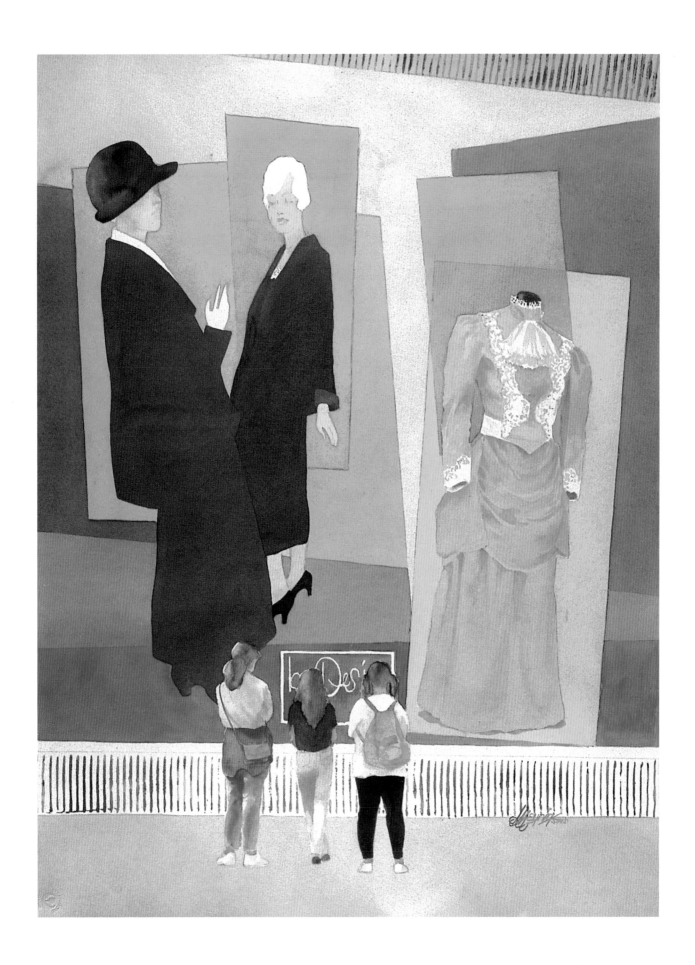

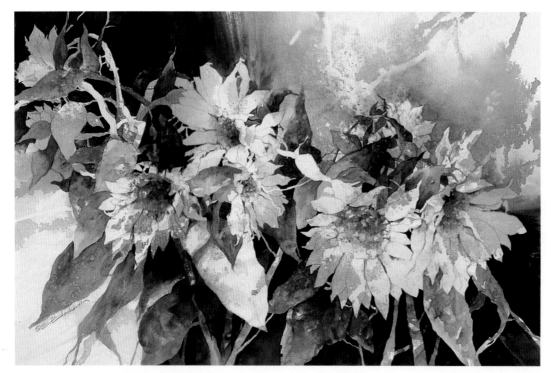

STEPHEN M. BLACKBURN
Sunbathe
18" × 28" (46 cm × 71 cm)
Crescent watercolor board
hot press

SHERRY LOEHR
Tapestry II
23" × 16" (58 cm × 41 cm)
Arches 140 lb. hot press
Watercolor and acrylic
(opposite)

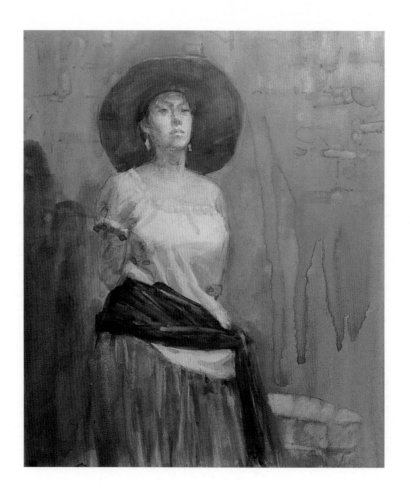

IRWIN GREENBERG
Leigh
11.5" × 10" (27 cm × 25 cm)
5-ply, plate-finish bristol board

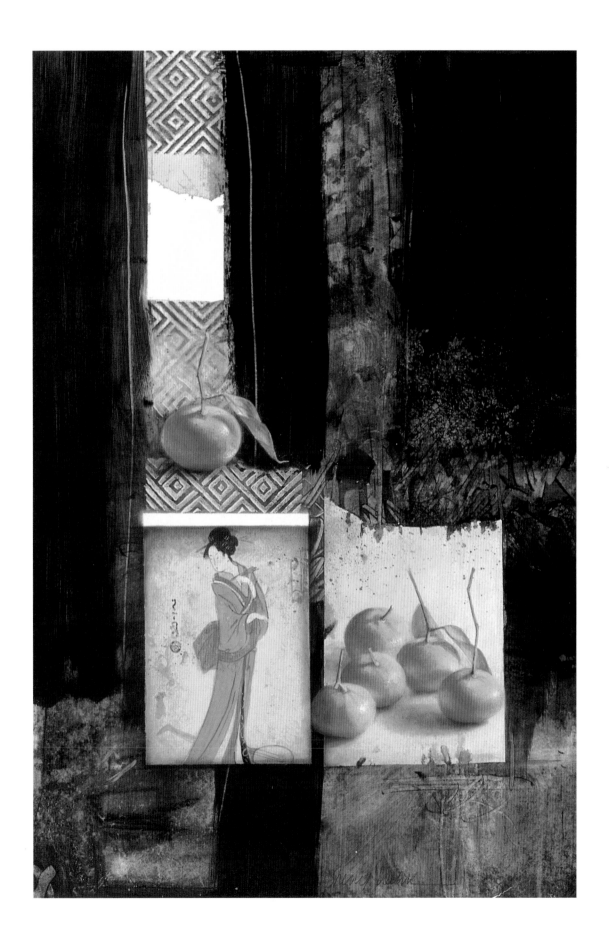

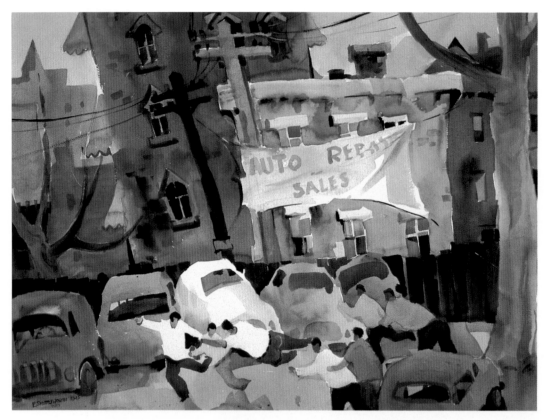

EDWIN C.
SHUTTLEWORTH
Saturday Afternoon

21.5" × 29.5" (55 cm × 75 cm)
Arches 140 lb. cold press

EDWARD L. WILLIMON
Luxor at Noon

21" × 14" (53 cm × 36 cm)
Saunders Waterford 140 lb.
cold press
(opposite)

BRIAN M. GORDY
Subliminally Upstream

22" × 30" (56 cm × 76 cm)
Arches 300 lb. cold press

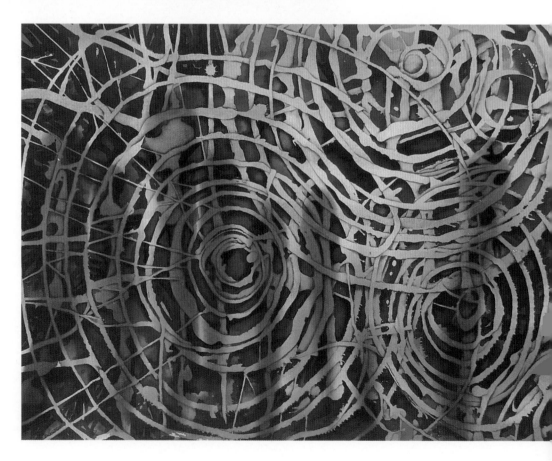

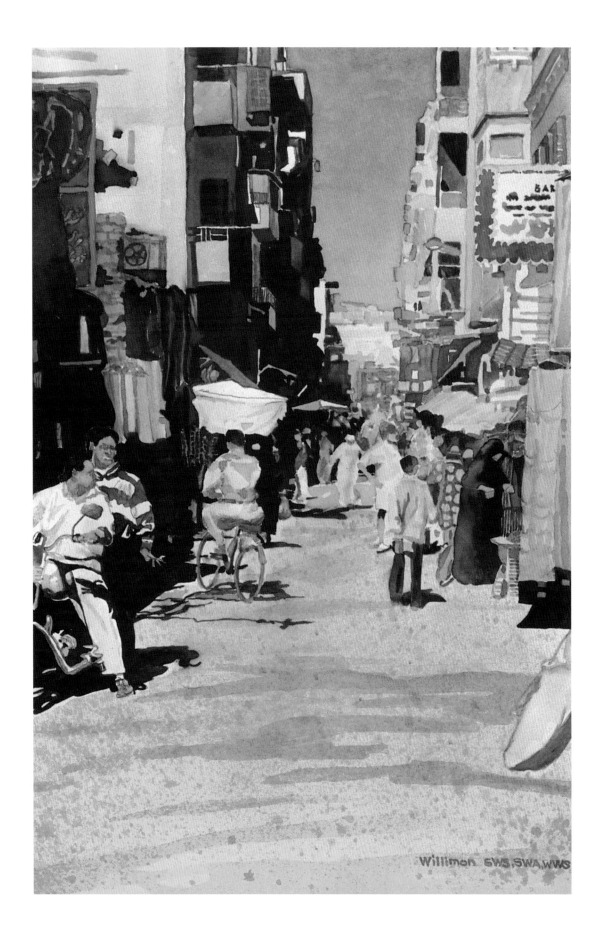

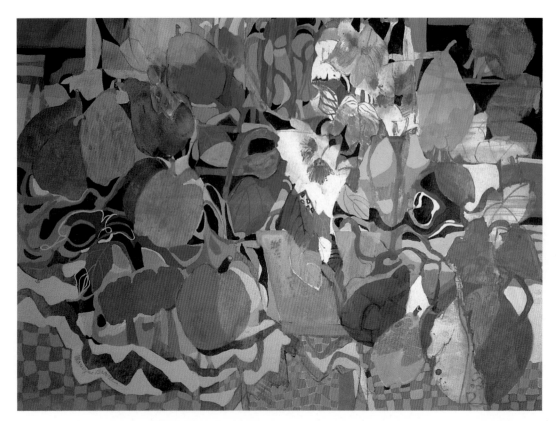

MARILYN BROWDE
Still Life I

22" × 30" (56 cm × 76 cm)
140 lb.
Watercolor, mixed media,
and acrylic

NEDRA TORNAY
Two Violet Irises

42" × 30" (76 cm × 51 cm)
Arches 555 lb. rough
(opposite)

LENA R. MASSARA
Abstract Pears

20" × 37" (51 cm × 94 cm)
Watercolor board
Watercolor, gouache, and pastel

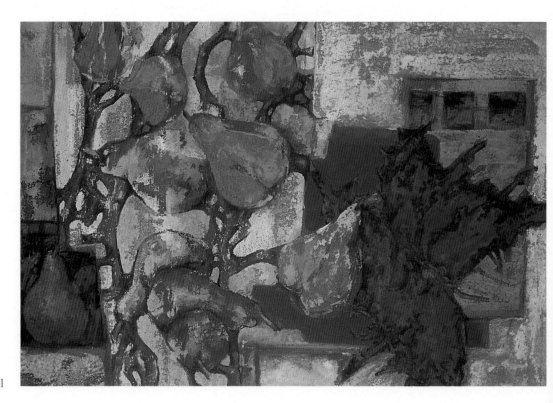

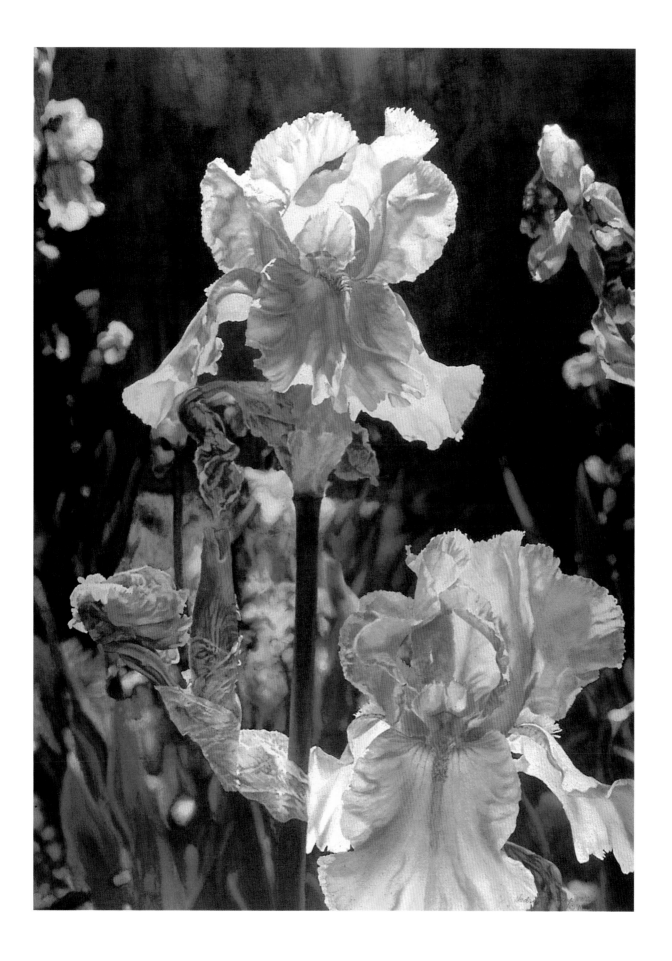

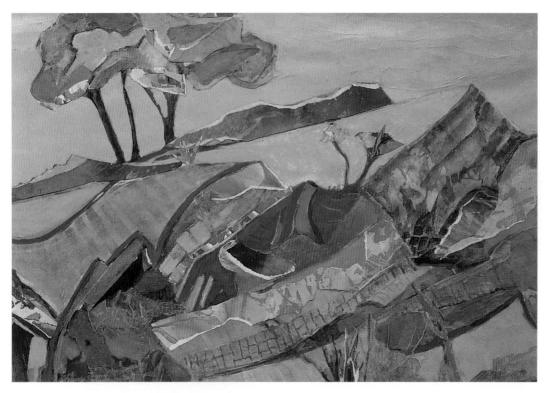

ASTRID E. JOHNSON
Pasture Land 2

24" × 32" (61 cm × 81 cm)
Arches 140 lb.
Watercolor and collage

MARY WILBANKS
Confrontation

30" × 20" (76 cm × 51 cm)
Illustration board
Watercolor, acrylic, and
watercolor pencils
(opposite)

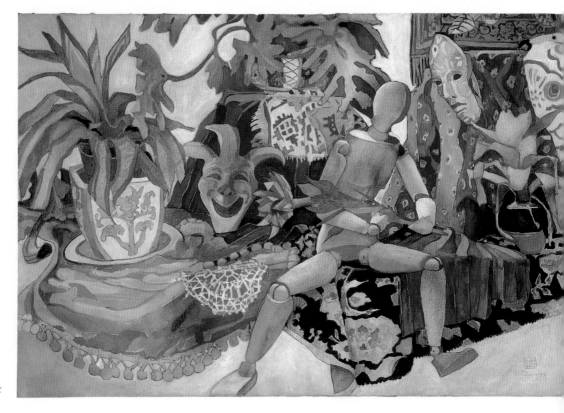

ANNE BAGBY
Still Life with Three Faces

24" × 36" (61 cm × 91 cm)
Arches 140 lb. cold press
Watercolor and white acrylic

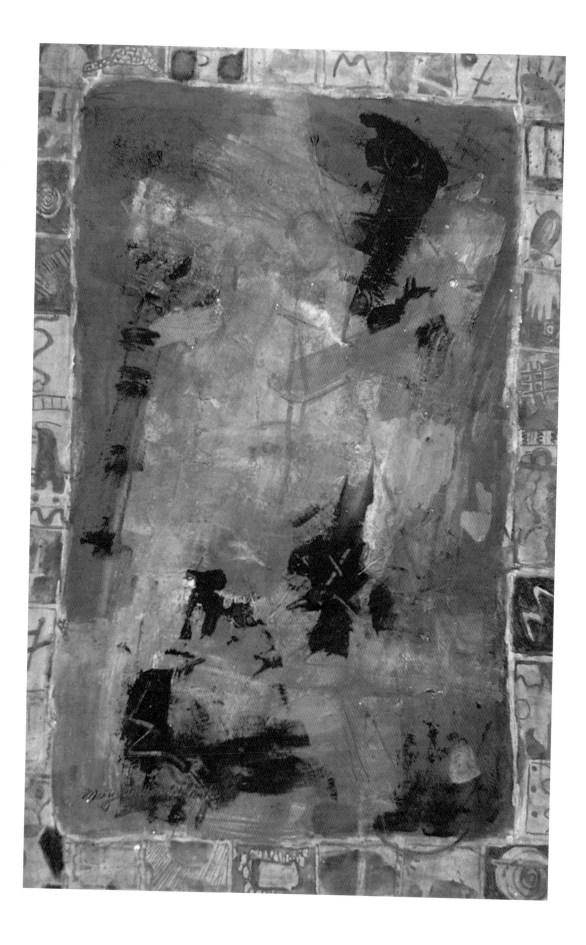

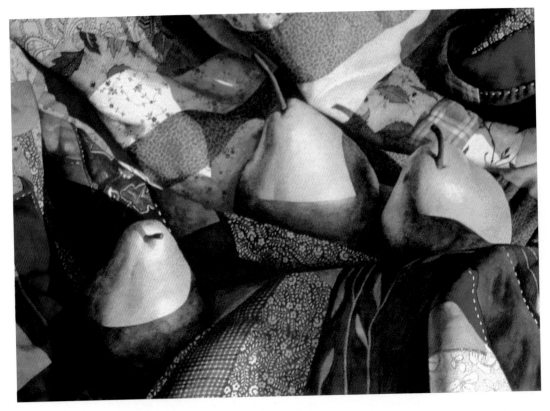

CHRIS KRUPINSKI
Lit Pears
22" × 30" (56 cm × 76 cm)
Arches 300 lb. rough

RALPH BUSH
Ocean Harvest
55" × 45" (140 cm × 114 cm)
Strathmore 500 140 lb.
cold press
Watercolor and white gouache
(opposite)

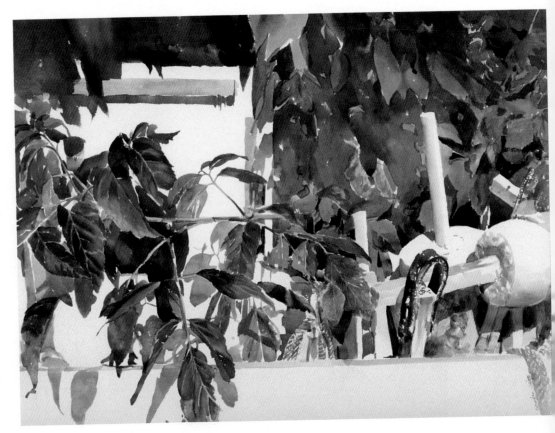

SANDRA SAITTO
Where the Land Meets the Sea 2
22" × 30" (56 cm × 76 cm)
Arches 140 lb. cold press

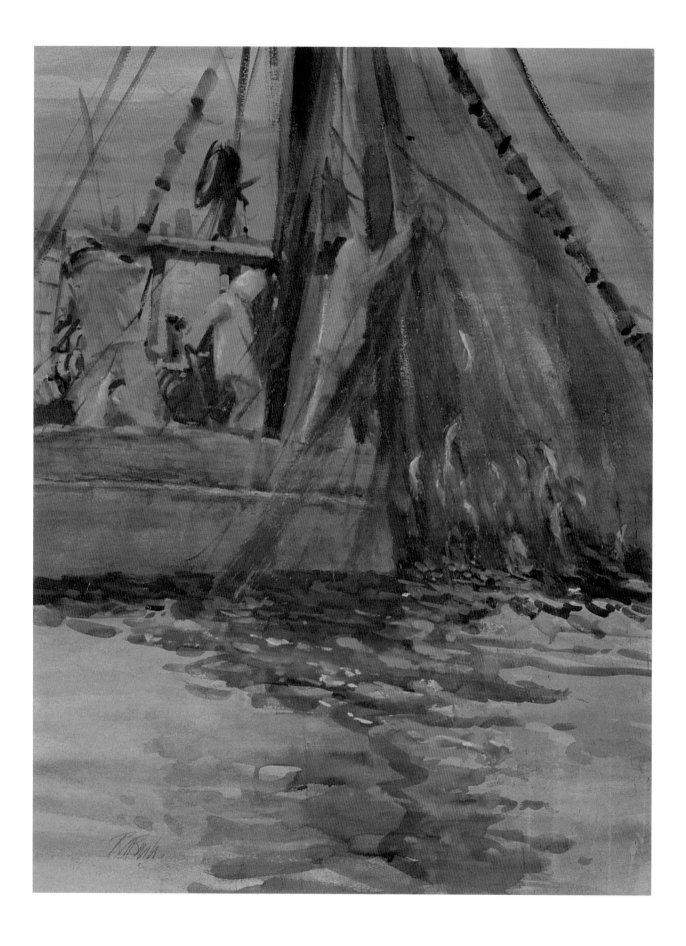

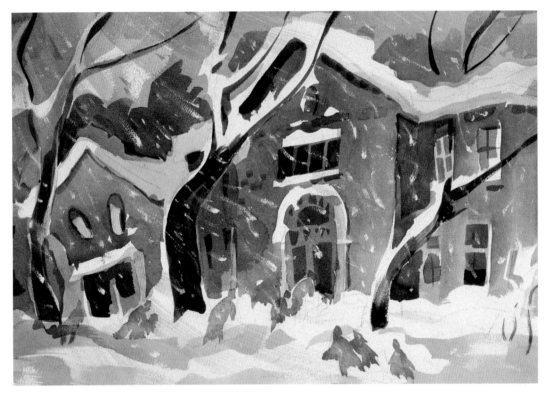

EDWIN C.
SHUTTLEWORTH
Guy Park School Days

14.5" × 21.5" (37 cm × 55 cm)
Arches 140 lb. cold press
Watercolor and opaque white
watercolor used for snowflakes

BARBARA K. BUER
Three White Peonies

30" × 22" (76 cm × 56 cm)
Arches 140 lb. cold press
Watercolor and fluid acrylics
(opposite)

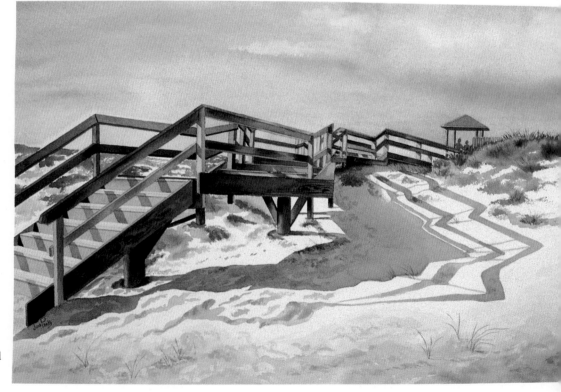

JUNE PARKS
Sand Patterns

26" × 36" (66 cm × 91 cm)
Strathmore watercolor board
cold press

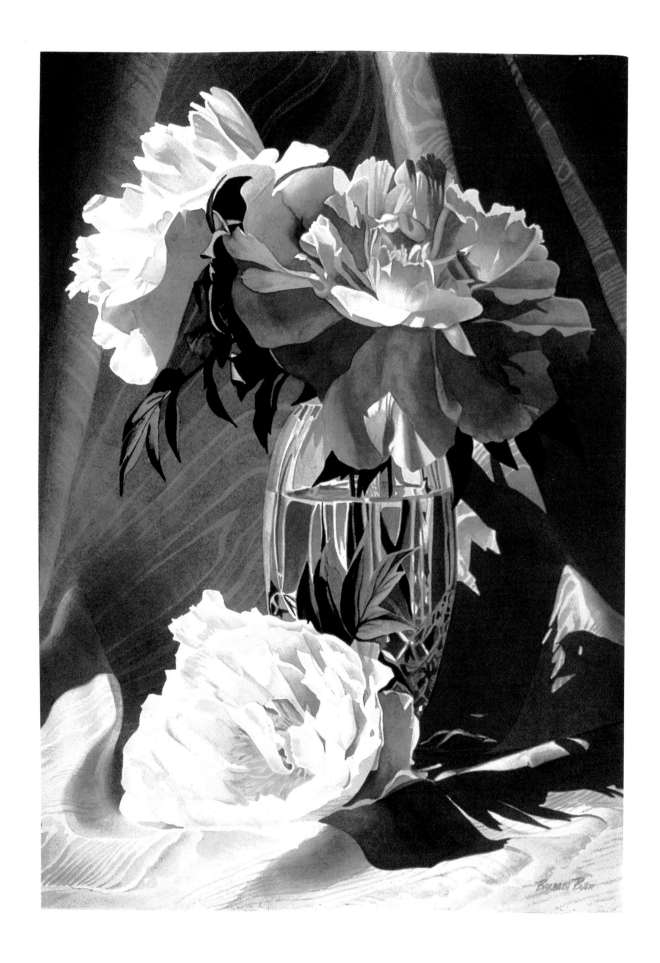

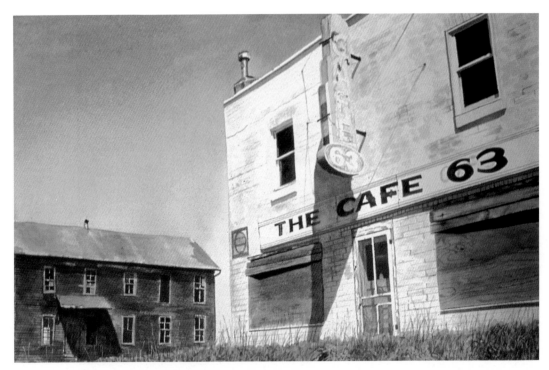

ROGER SCHOLBROCK
Cafe 63

11.5" × 18" (29 cm × 46 cm)
Arches 140 lb. cold press

SHIRLEY ZAMPELI
STURTZ-DAVIS
Prognosticator of the Tin Toys

28" × 20" (71 cm × 51 cm)
Arches 300 lb.
(opposite)

PATRICIA HARRINGTON
Sienna Woods

20" × 28" (51 cm × 71 cm)
Aquarius paper
Watercolor and acrylic washes

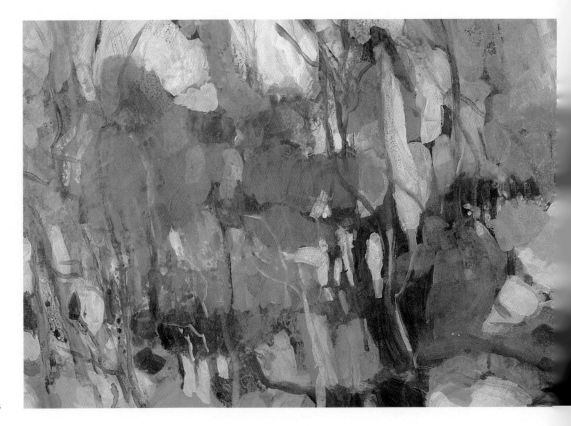

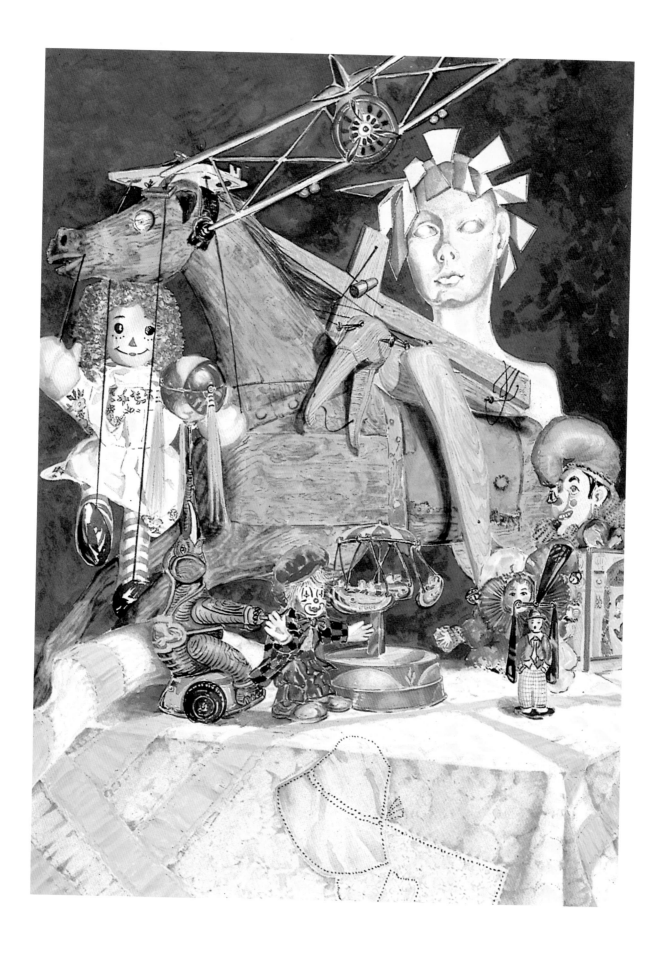

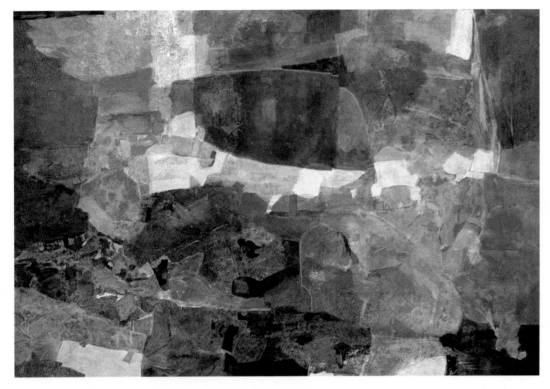

TODD CHALK
Washday Blues

22" × 30" (56 cm × 76 cm)
Strathmore Aquarius II
Watercolor, acrylic, and
watercolor crayon

MARIE SHELL
Butterfly Series 5: Fluttering Memories

30" × 22" (76 cm × 56 cm)
Arches 140 lb. cold press
Watercolor and collage
(opposite)

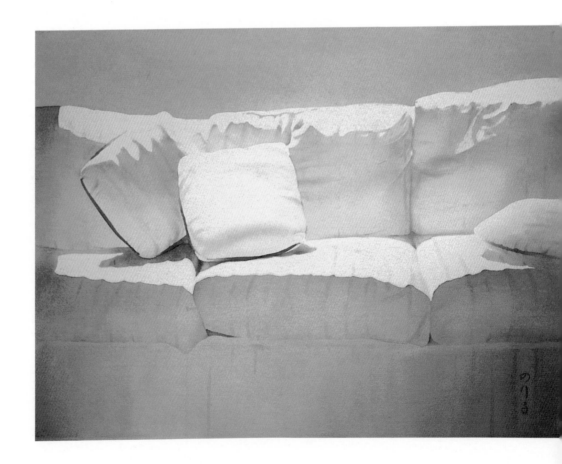

NORIKO HASEGAWA
White on White

22" × 30" (56 cm × 76 cm)
Arches 300 lb. rough

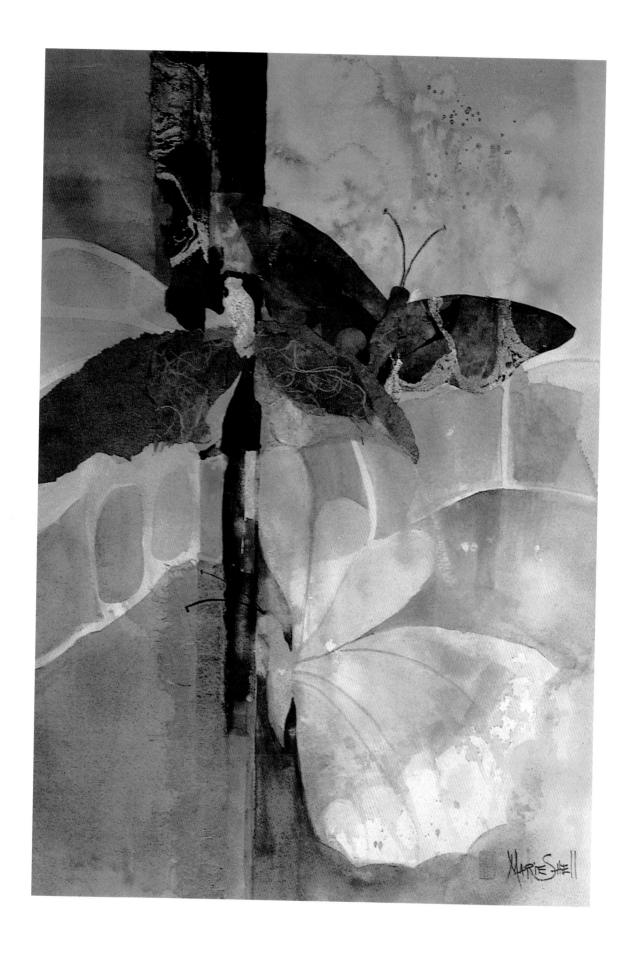

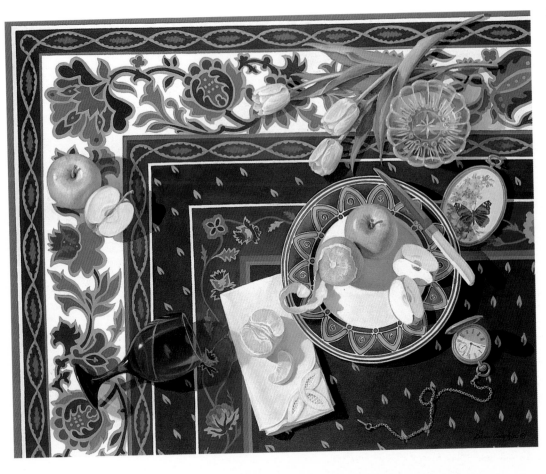

LINDA TOMPKIN
Harmony
24" × 30" (61 cm × 76 cm)
Strathmore Series watercolor
board 500 lb.
Watercolor and acrylic

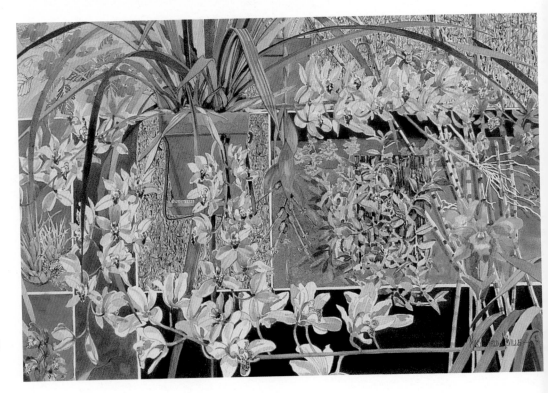

MARY FIELD NEVILLE
Tapestry Two
19" × 29.25" (48 cm × 74.5 cm)
Crescent watercolor board
cold press

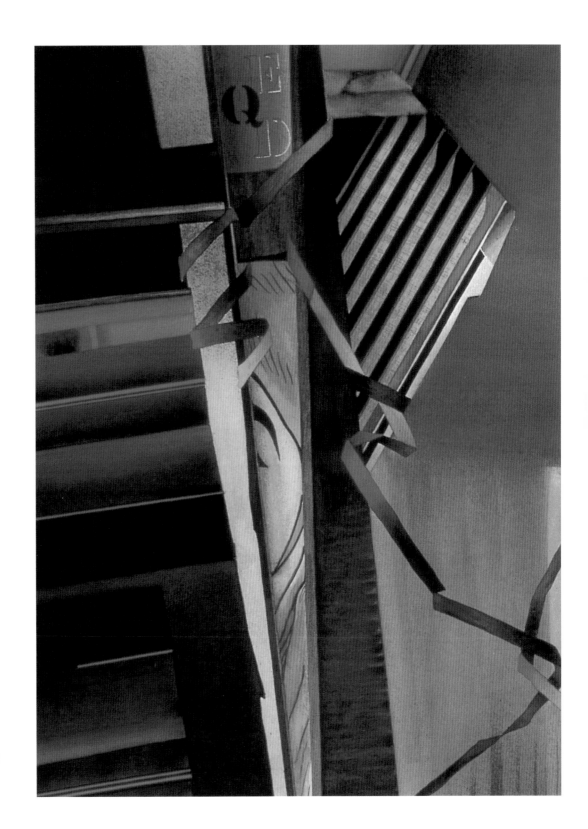

H. C. DODD

The Sound of Red

30" × 22" (76 cm × 56 cm)
Winsor & Newton 260 lb.
cold press

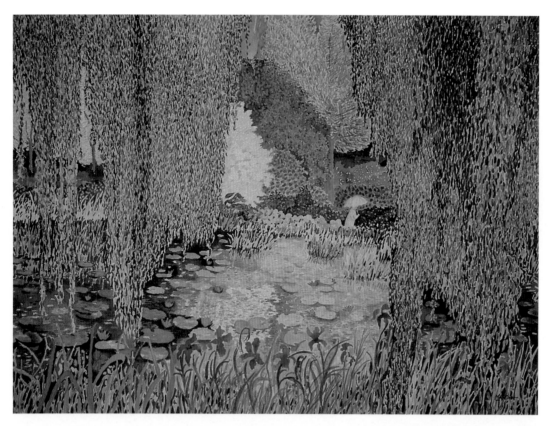

LILLIAN MARLATT
Giverny June Showers 1
22" × 30" (56 cm × 76 cm)
Arches 140 lb. cold press

MATHILDE LOMBARD
Casual
19" × 14" (48 cm × 36 cm)
Shoellershammer 102 lb.
cold press
Watercolor and water-soluble ink
(opposite)

ROSALIE HARRIS CECIL
Breakthrough
21" × 26.25" (53 cm × 66.5 cm)
Arches 140 lb. cold press
Watercolor and acrylic

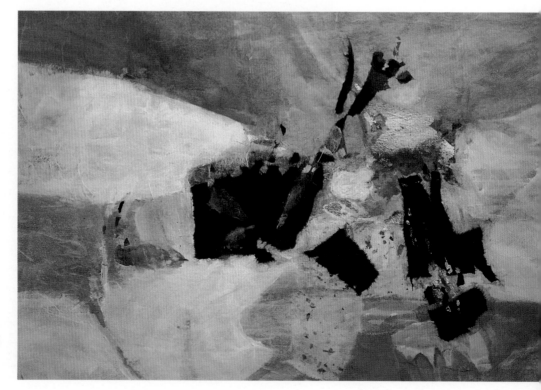

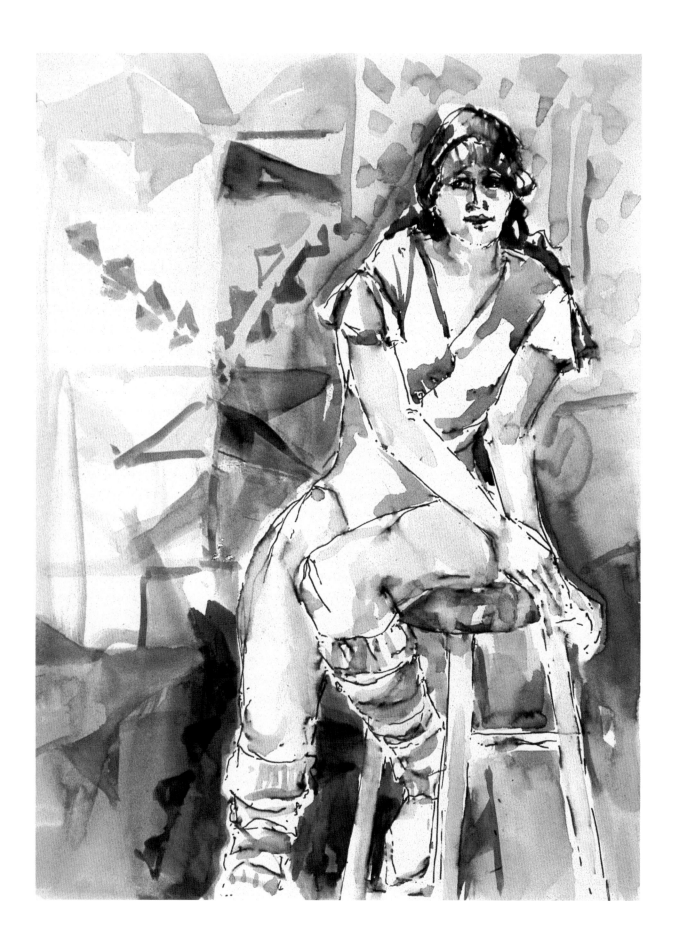

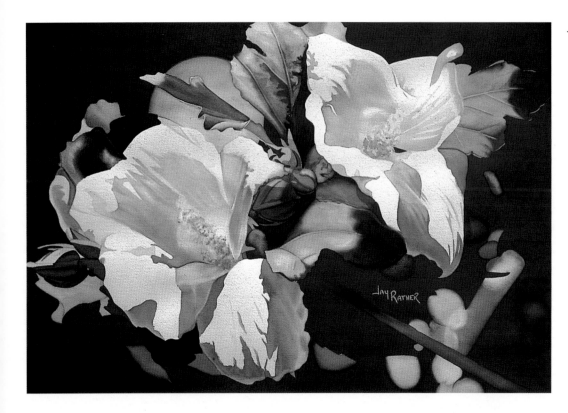

JAY RATHER
Rose Althea II

22" × 30" (56 cm × 76 cm)
Arches 140 lb. rough

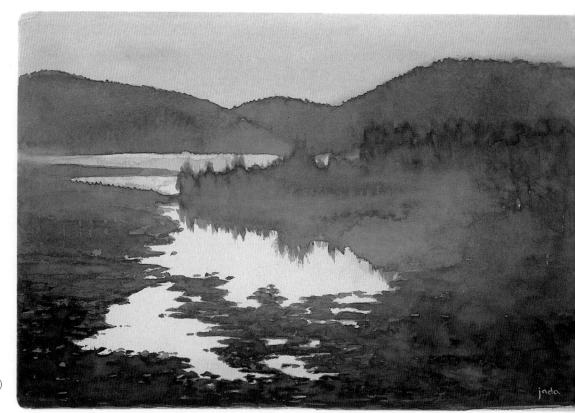

JADA ROWLAND
Hudson River Sunset

9" × 12" (23 cm × 30 cm)
Arches 140 lb. hot press

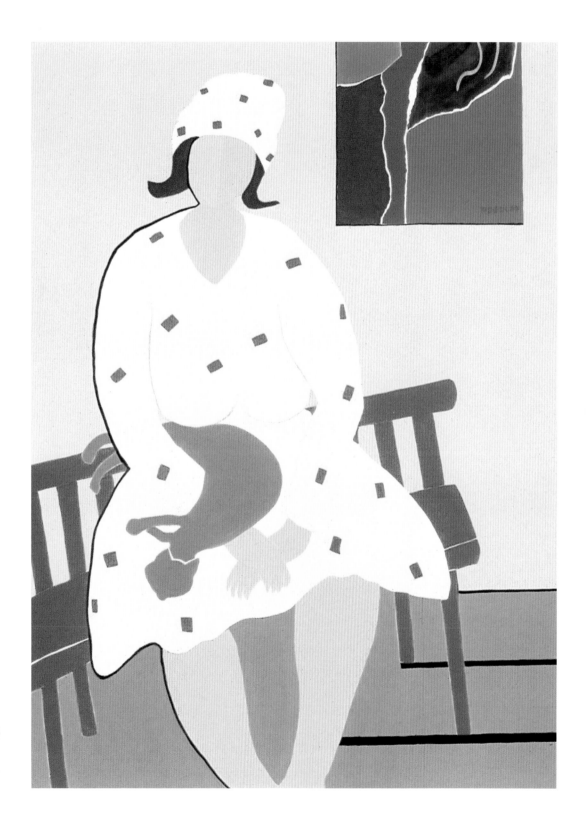

HELEN NEEDLES
The Museum Closes at Five!
40" × 30" (102 cm × 76 cm)
Crescent 115 lb. hot press
Watercolor, acrylic, gouache,
and gesso

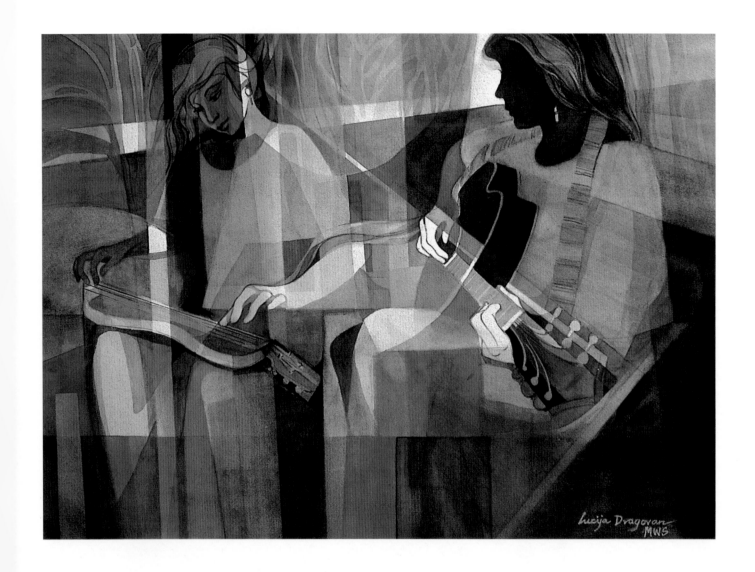

LUCIJA DRAGOVAN
Afternoon Rhythm

22" × 30" (56 cm × 76 cm)
140 lb. cold press

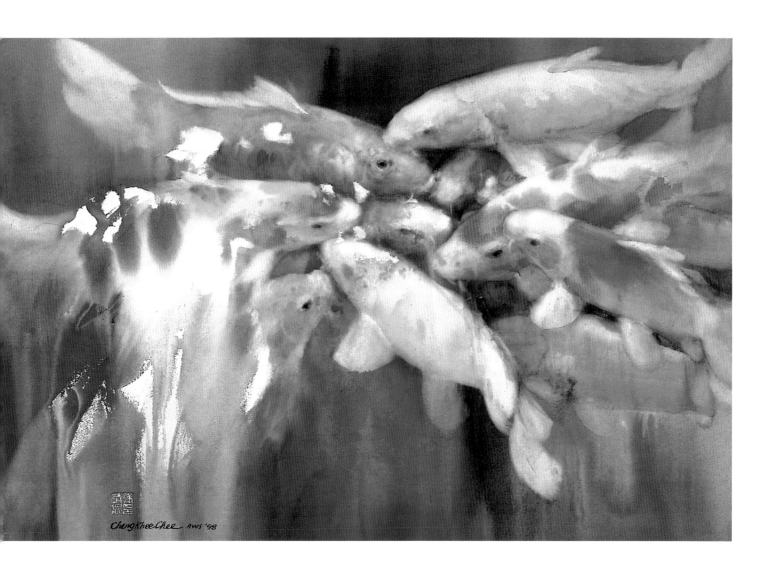

CHENG-KHEE CHEE
Koi 98 No. 1

30" × 41" (76 cm × 104 cm)
Arches 555 lb. cold press

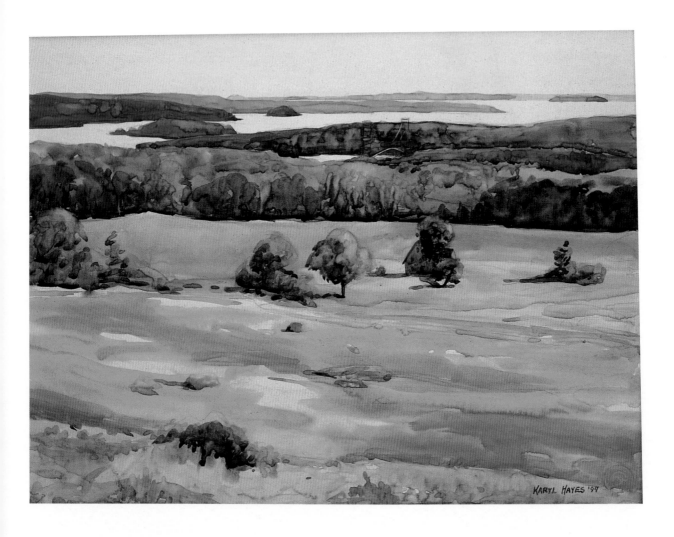

KARYL R. HAYES
Blueberries and Beyond

14.75" × 19.75" (37.5 cm × 50.5 cm)
Strathmore illustration board
plate surface

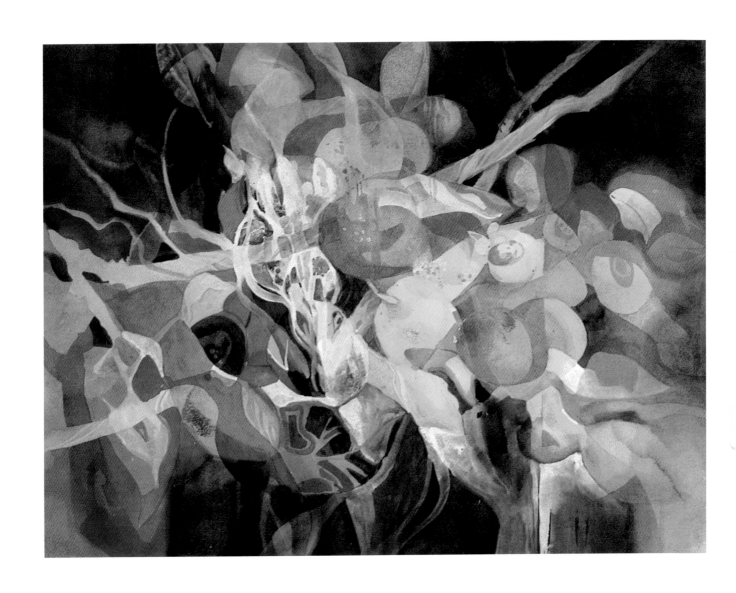

MARGE McCLURE
Orchard Shapes

23" × 30" (58 cm × 76 cm)
Arches 300 lb. cold press
Watercolor and gesso

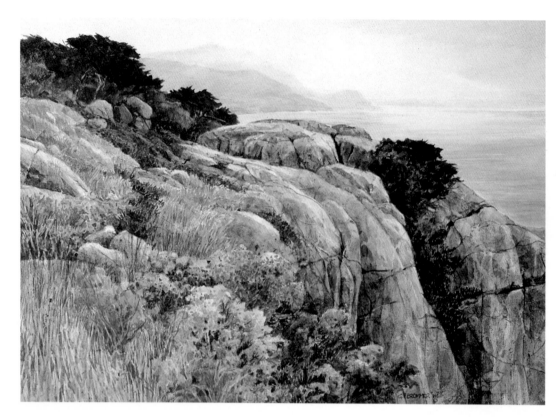

GERALD F. BROMMER
Point Lobos Color

22" × 30" (56 cm × 76 cm)
Arches 300 lb. rough
Watercolor and collage

MARIETTA PETRINI
August

42" × 31" (107 cm × 79 cm)
Arches 300 lb. hot press
(opposite)

HELLA BAILIN
Confrontation

21" × 29" (53 cm × 74 cm)
Illustration board
Watercolor, mixed media,
and collage

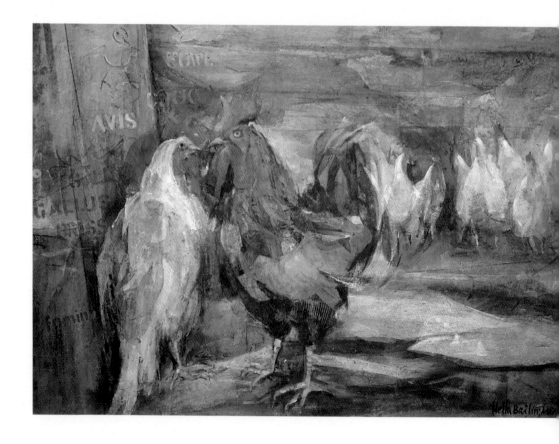

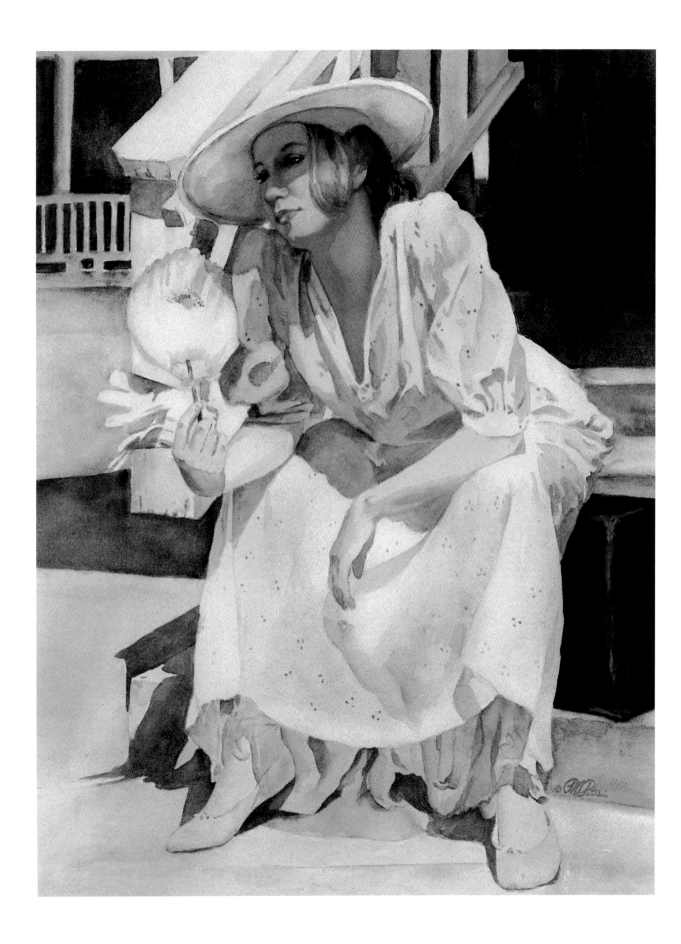

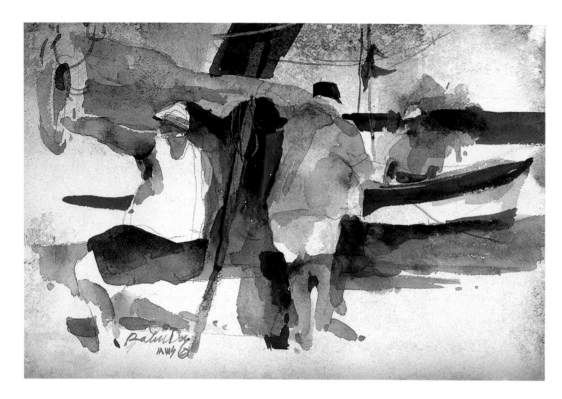

RATINDRA K. DAS
Men from Mismaloya
15" × 22" (38 cm × 56 cm)
Handmade Indian paper 140 lb.

WOLODIMIRA VERA WASIEZKO
Showy Moment
36" × 26" (91 cm × 66 cm)
Crescent 100% rag hot press
Watercolor and acrylic
(opposite)

MARRON F. McDOWELL
Oblique Oscillation
22" × 30" (56 cm × 76 cm)
Strathmore Aquarius II 80 lb.
cold press
Watercolor and acrylic

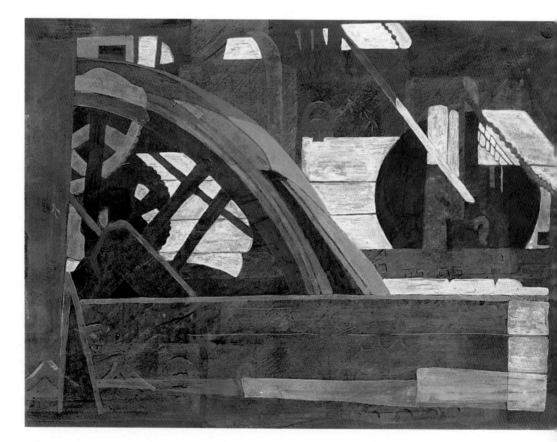

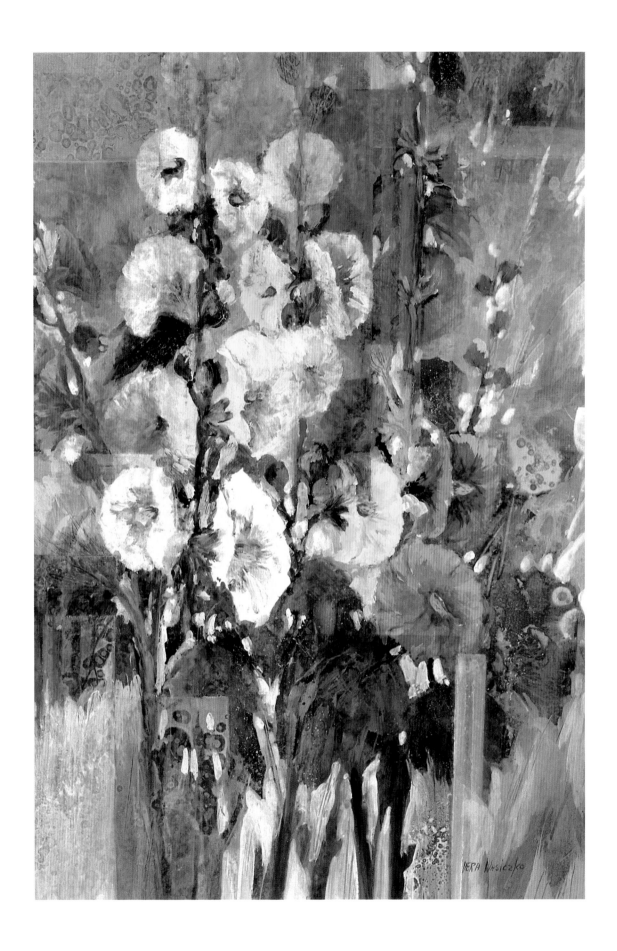

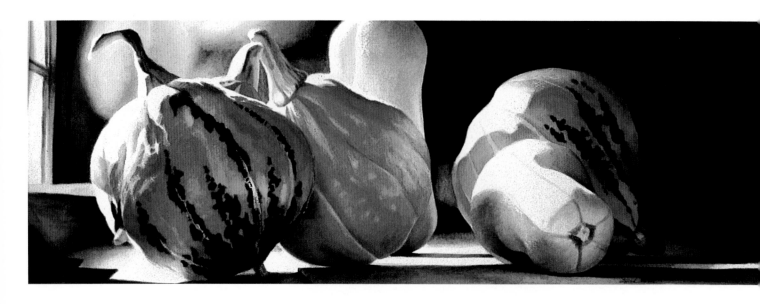

JANET LAIRD-LAGASSEE
Let There Be Light

7.75" × 21.75" (19.5 cm × 55.5 cm)
Arches 140 lb. cold press

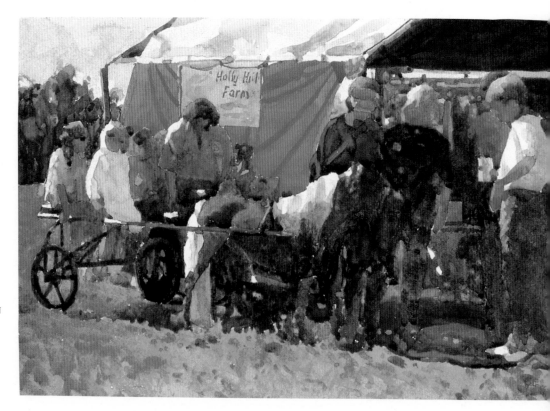

ANNE ADAMS ROBERTSON
MASSIE
Pony Cart

22" × 28" (56 cm × 71 cm)
Fabriano Artistico 140 lb.

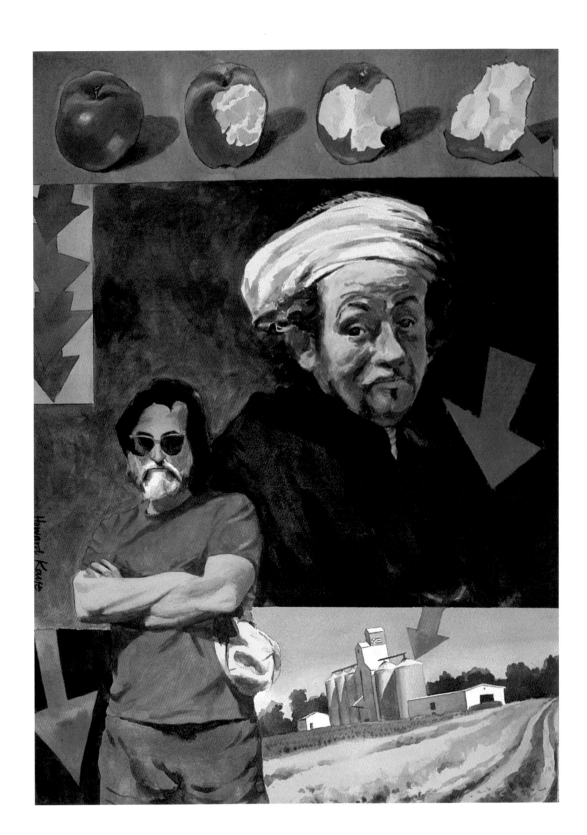

HOWARD KAYE
Rembrandt 1
29" × 21" (74 cm × 53 cm)
Arches 140 lb. cold press

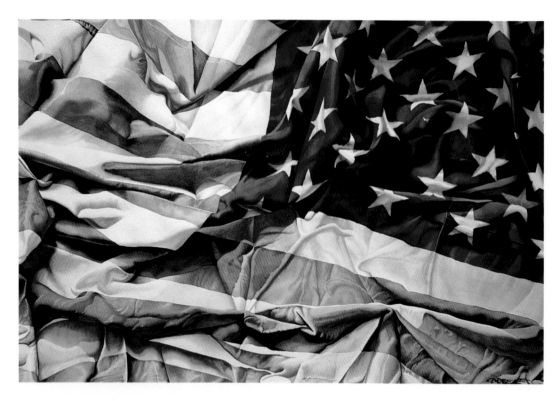

JOSEPH CORREALE
Faded Glory
21" × 28" (53 cm × 71 cm)
Arches 300 lb. cold press

ANN MITCHELL
Three Women
24" × 18" (61 cm × 46 cm)
Arches 140 lb. hot press
(opposite)

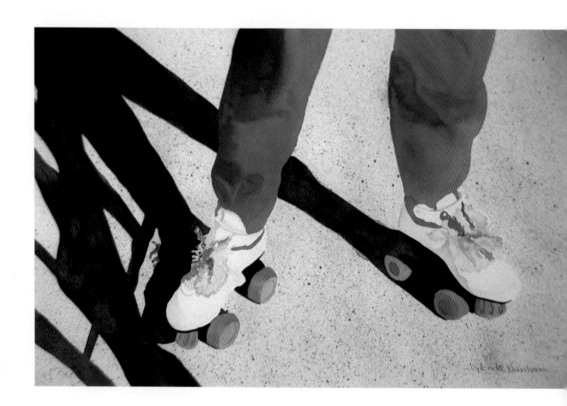

GLENDA DUNHAM
Jenny's New Skates
14" × 21" (36 cm × 53 cm)
Arches 140 lb. cold press

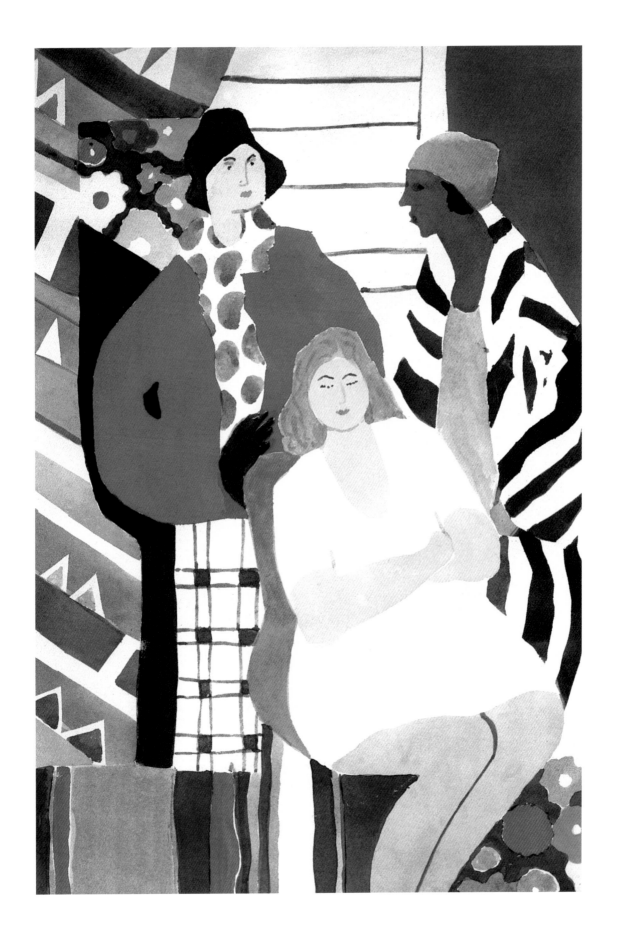

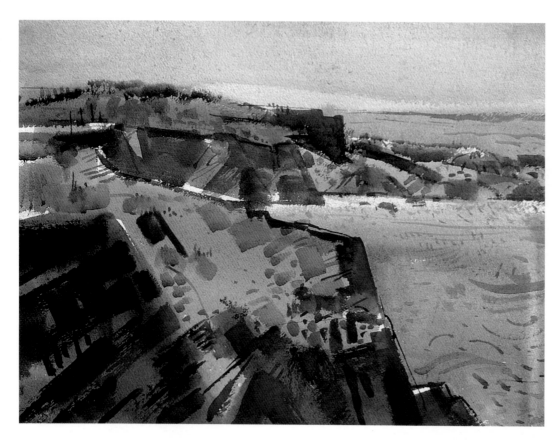

JOHN BARNARD
Leffingwell Landing
20" × 28" (51 cm × 71 cm)
Handmade (Indian village)
200 lb. rough

MICKEY DANIELS
Traces of Time
20" × 14" (51 cm × 36 cm)
Arches 140 lb. cold press
(opposite)

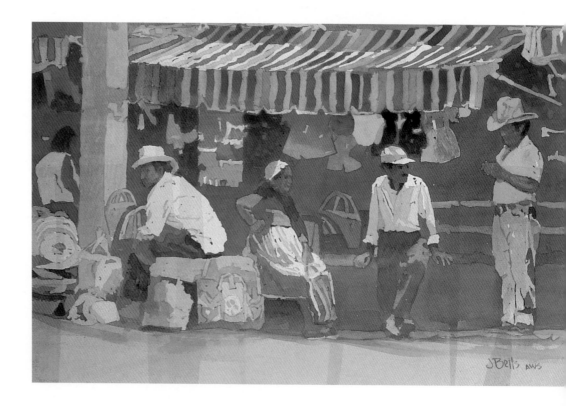

JUDI BETTS
Sunscreen
15" × 22" (38 cm × 56 cm)
Arches 140 lb. cold press

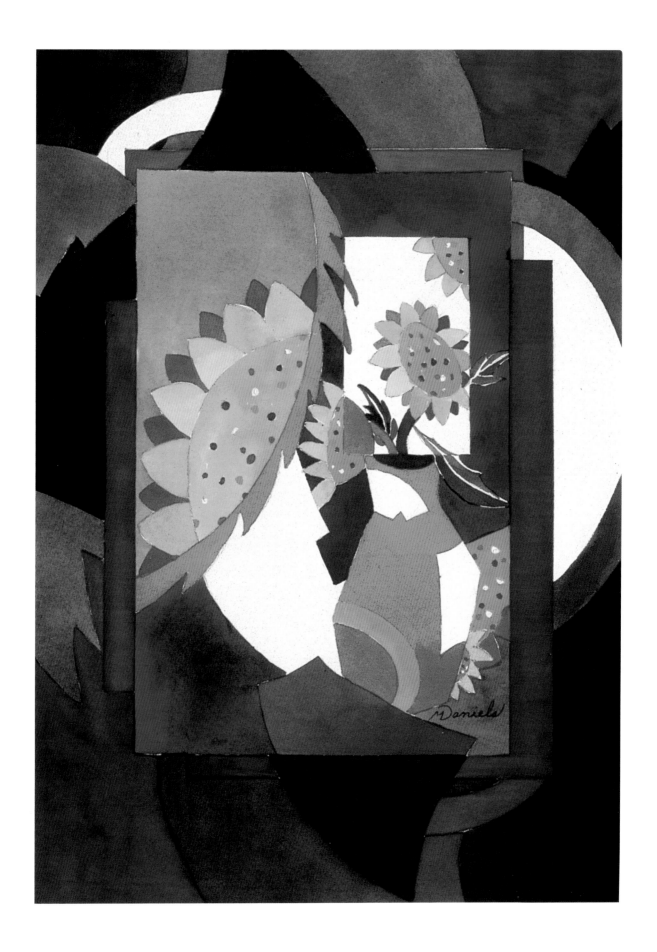

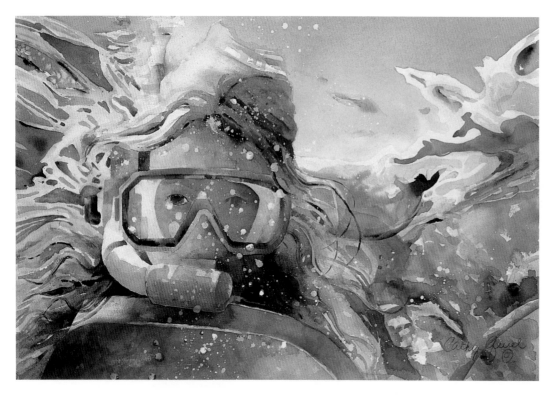

CATHY QUIEL
Submerged I
15" × 22" (38 cm × 56 cm)
Arches 140 lb. cold press

MILES G. BATT SR.
Unsportsmanlike Conduct
15" × 11" (38 cm × 28 cm)
Arches 140 lb. hot press
(opposite)

WILLAMARIE HUELSKAMP
Navajo Mountain Cloud
22" × 30" (56 cm × 76 cm)
Lanaquerelle 300 lb.
cold press
Watercolor and underpainting
with Quinacridone colors

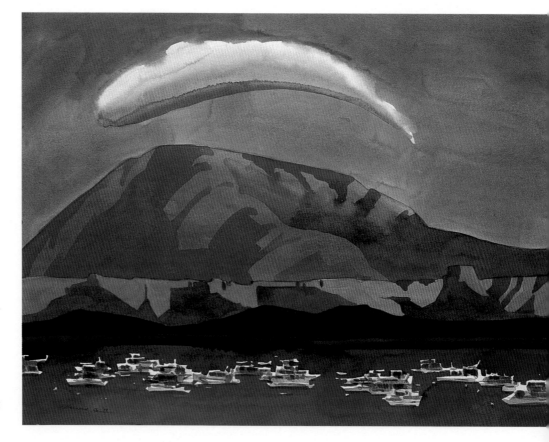

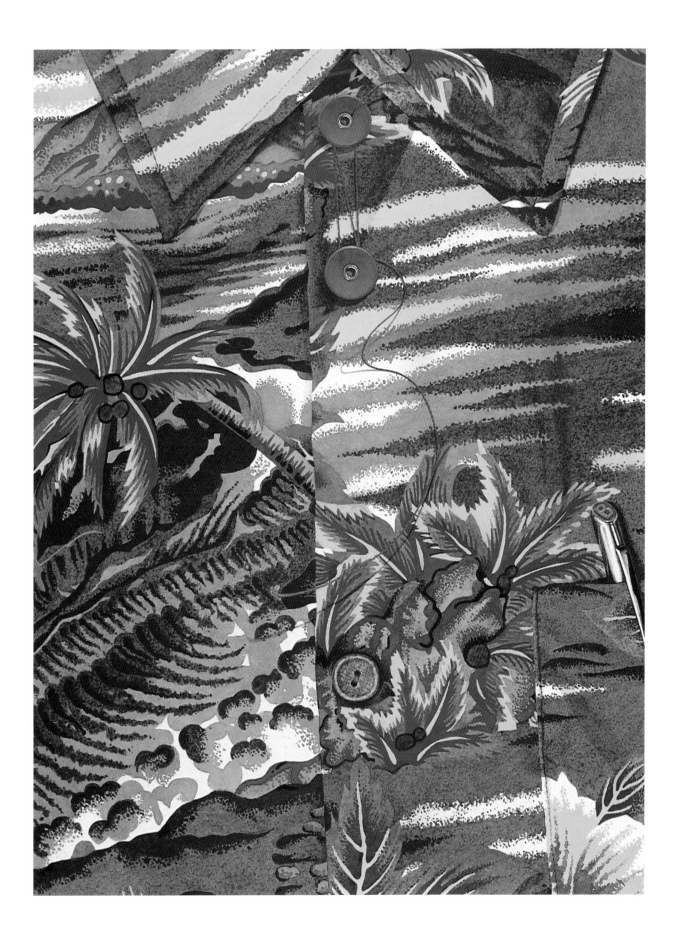

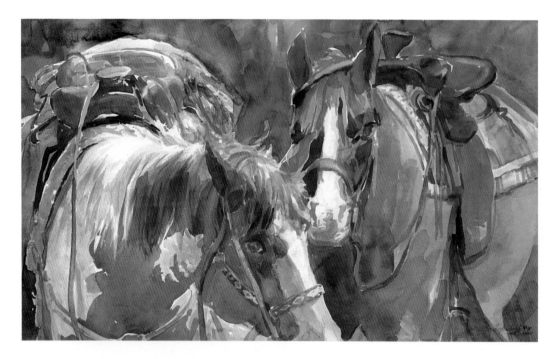

ELLEN JEAN DIEDERICH
Anticipation

24.25" × 39.25"
(62 cm × 100 cm)
Arches Double Elephant 260 lb.
cold press

SHARON TOWLE
A Goldfish Named Matisse

4" × 5" (10 cm × 13 cm)
Arches 140 lb. cold press
(opposite)

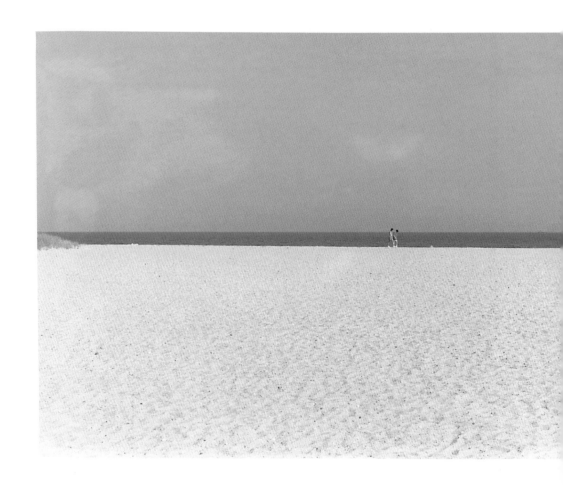

KUO YEN NG
A Walk on the Wild Side

21" × 29" (53 cm × 74 cm)
Arches 300 lb.

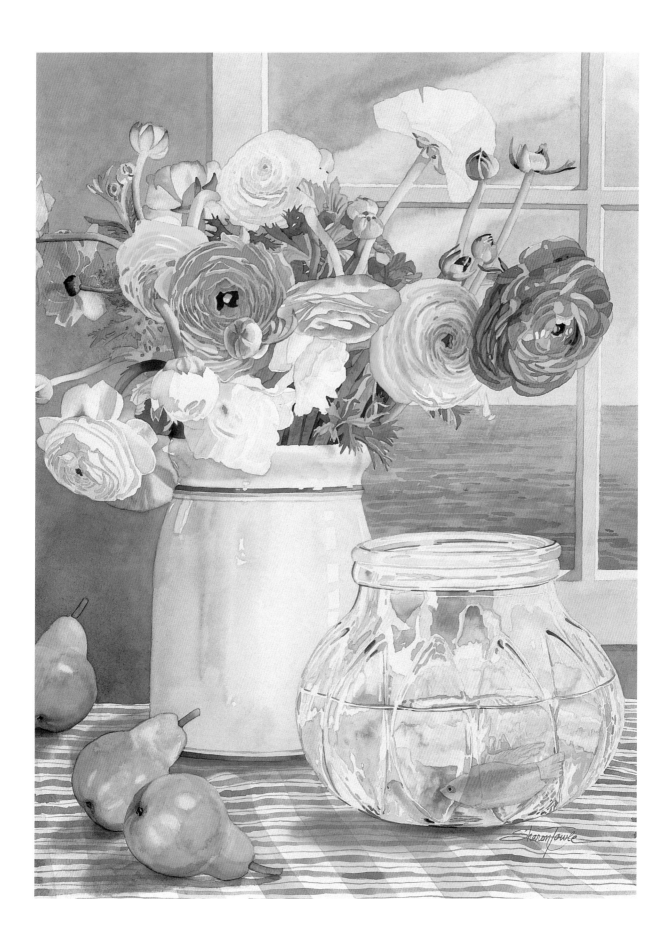

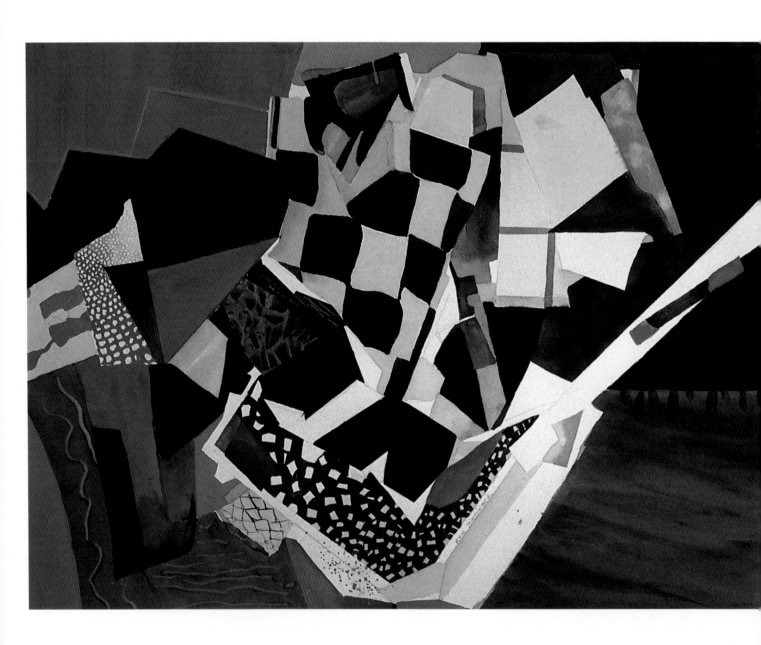

AVIE BIEDINGER

All Thoughts of Turtles are Turtles

22" × 30" (56 cm × 76 cm)
Arches 140 lb. cold press

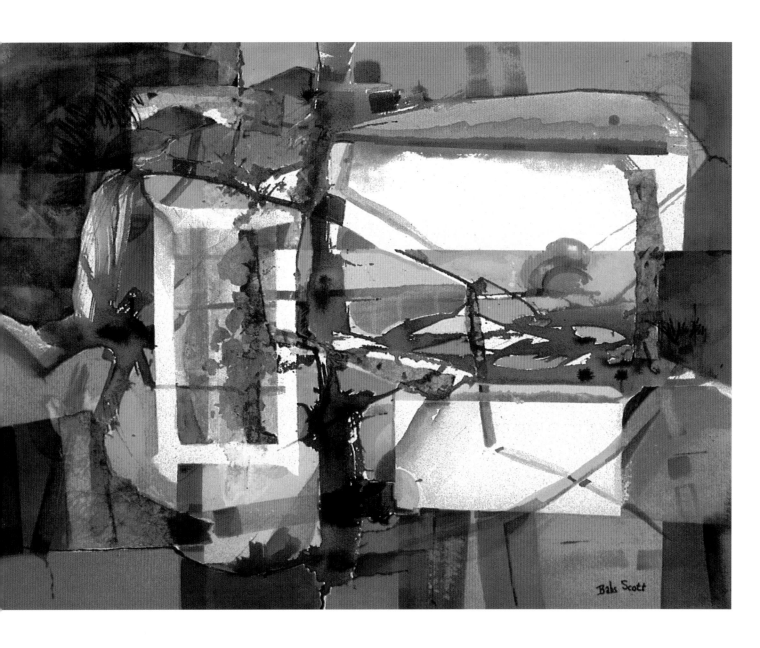

BABS SCOTT
Going Through
35" × 27" (89 cm × 69 cm)
Arches 150 lb.

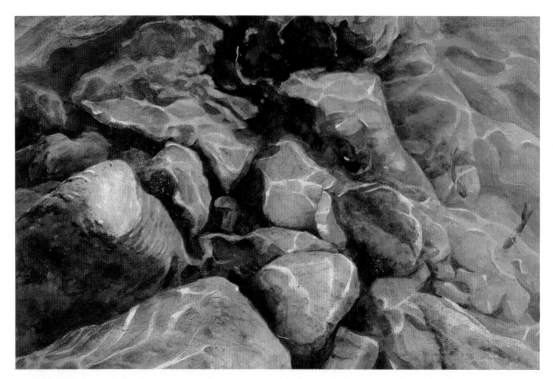

SHIRLEY STERLING
Cayman Reflections

22" × 30" (56 cm × 76 cm)
Lanaquarelle 140 lb. cold press
Watercolor and matte medium

HERB RATHER
Texas & Pacific

30" × 22" (76 cm × 56 cm)
Arches 140 lb. rough
(opposite)

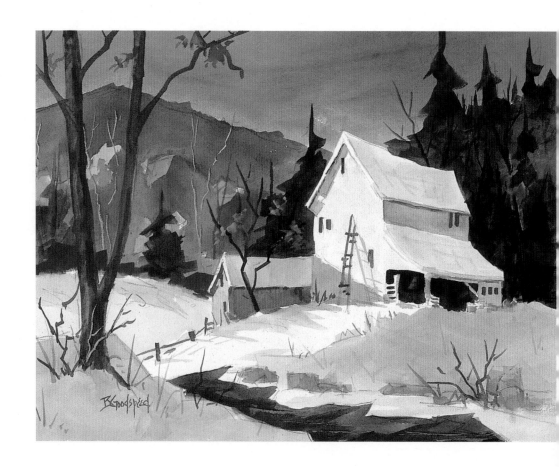

BARBARA GOODSPEED
Midwinter

18" × 24" (46 cm × 61 cm)
Arches 140 lb. cold press

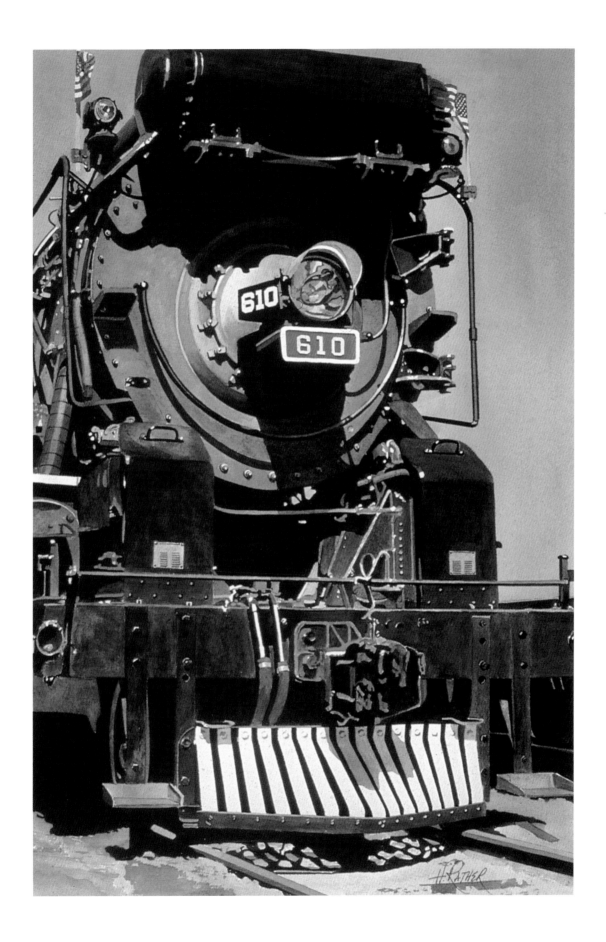

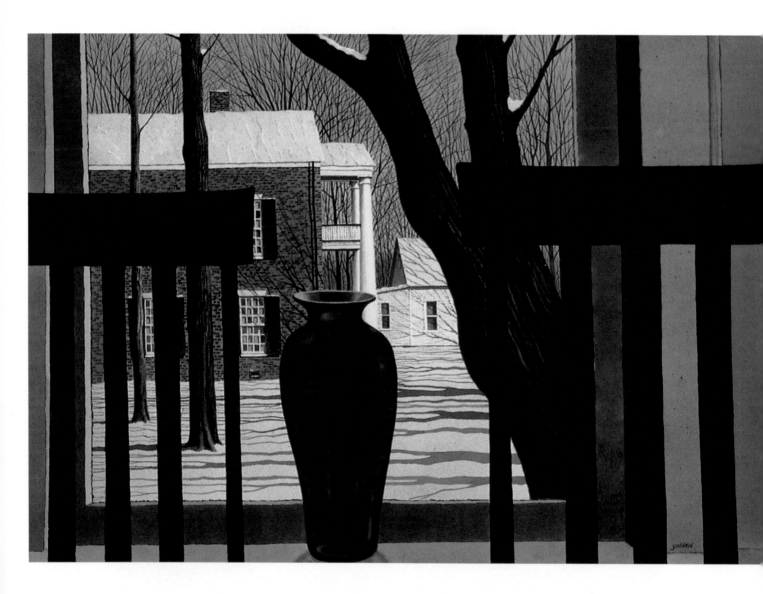

ROLLAND GOLDEN

Lexington Views II

23.5" × 33.5" (60 cm × 85 cm)
Arches 250 lb. cold press
Watercolor and gouache

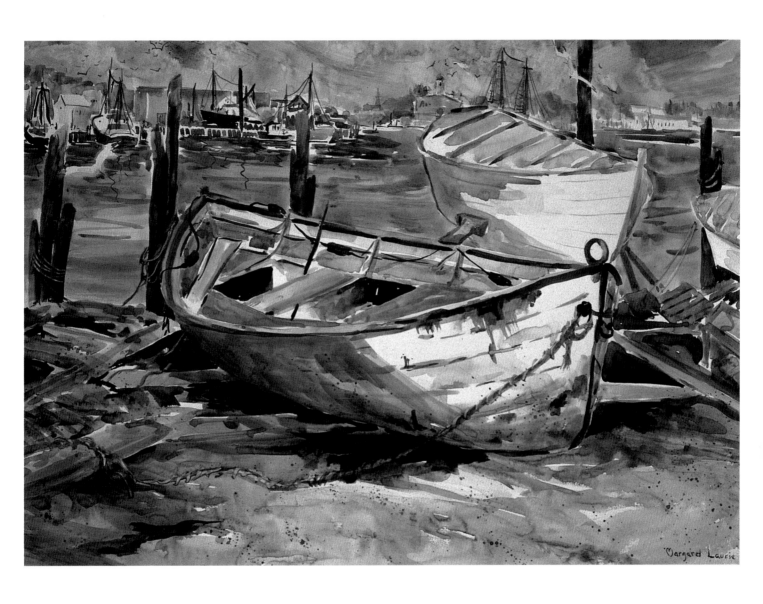

MARGARET LAURIE
The Derelict

26" × 32" (66 cm × 81 cm)
Arches 260 lb.

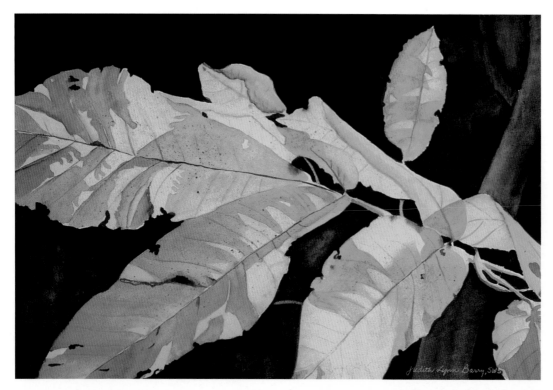

JUDITH LYNN BARRY
Sun Struck

15" × 22" (38 cm × 56 cm)
Saunders Waterford 140 lb.
cold press

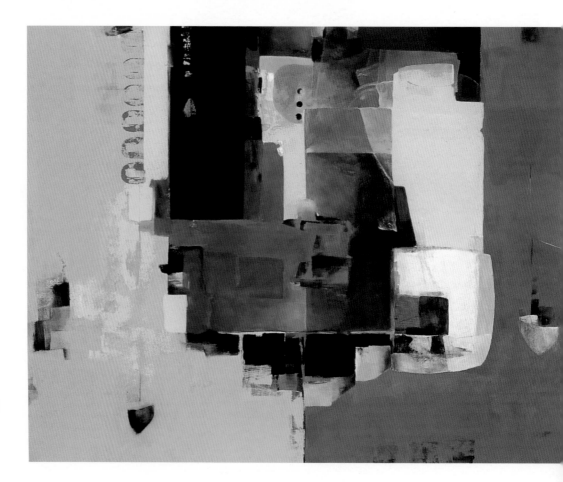

DIANE LOUNSBERRY-
WILLIAMS

Hanging in the Balance

32" × 40" (81 cm × 102 cm)
4-ply rag board
Watercolor, acrylic, and
color pencils

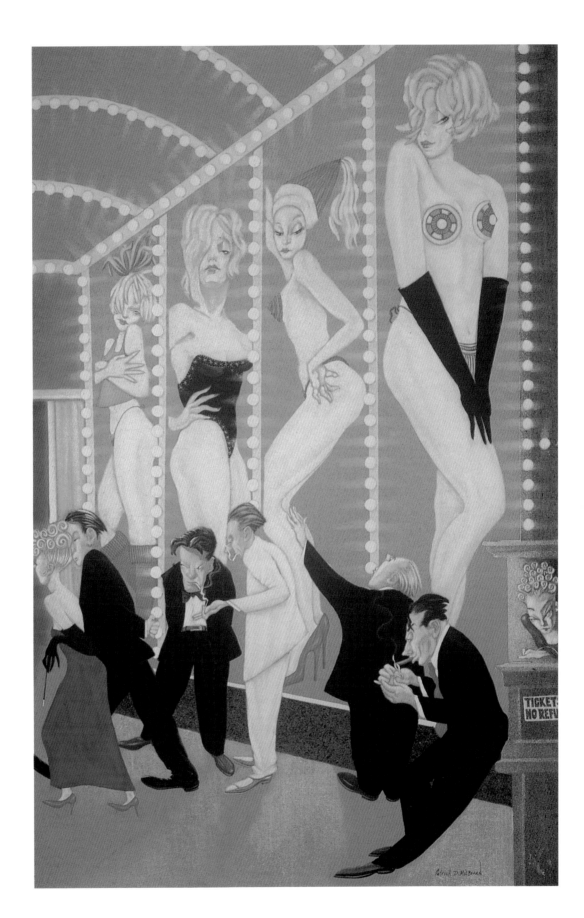

PATRICK D. MILBOURN
South Side Johnny
36" × 24" (91 cm × 61 cm)
Arches 300 lb. hot press
Watercolor and gouache

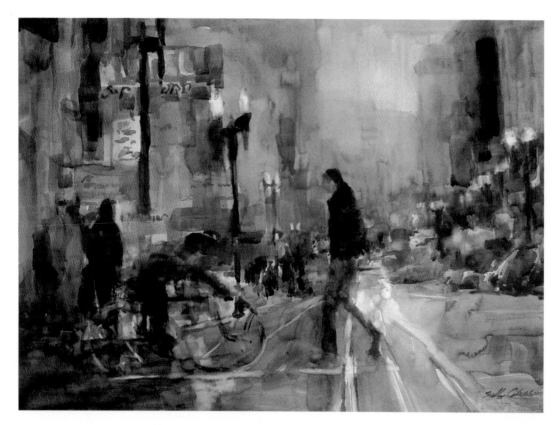

SALLY CATALDO
California Street
22" × 30" (56 cm × 76 cm)
Winsor & Newton 140 lb.
Watercolor and watercolor
pencil

DAVID L. STICKEL
Drawn to the Light
22" × 15" (56 cm × 38 cm)
Arches
(opposite)

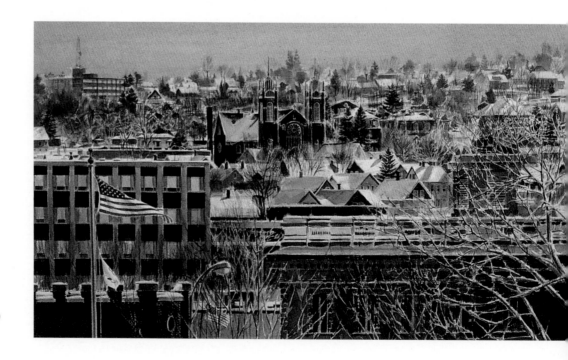

NICHOLAS SCALISE
Rooftops
18" × 30" (46 cm × 76 cm)
90 lb. cold press

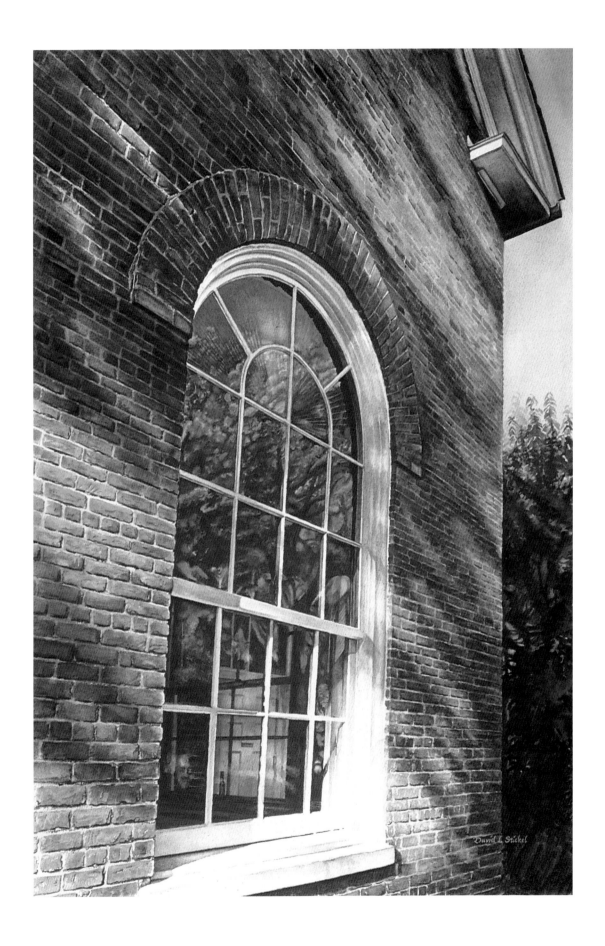

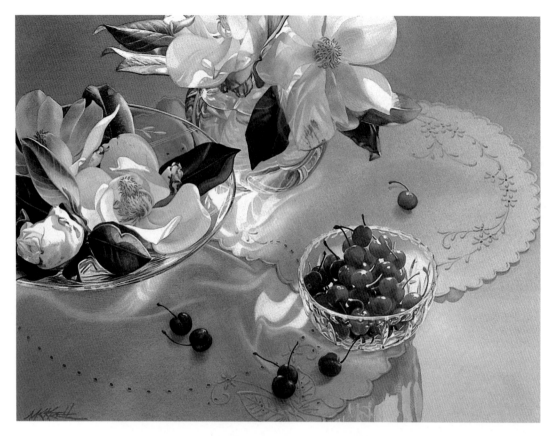

MARY KAY KRELL
Spring Gathering
19" × 25" (48 cm × 64 cm)
Arches 300 lb. cold press
Watercolor and white gouache

MARIANNE K. BROWN
Tied Up V
30" × 22" (76 cm × 56 cm)
Arches 140 lb.
(opposite)

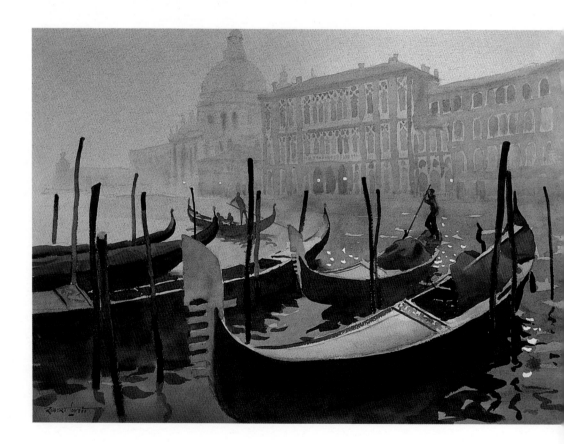

ROBERT LOVETT
Wet Day—Venice
12" × 16" (30 cm × 41 cm)
Arches 300 gsm rough

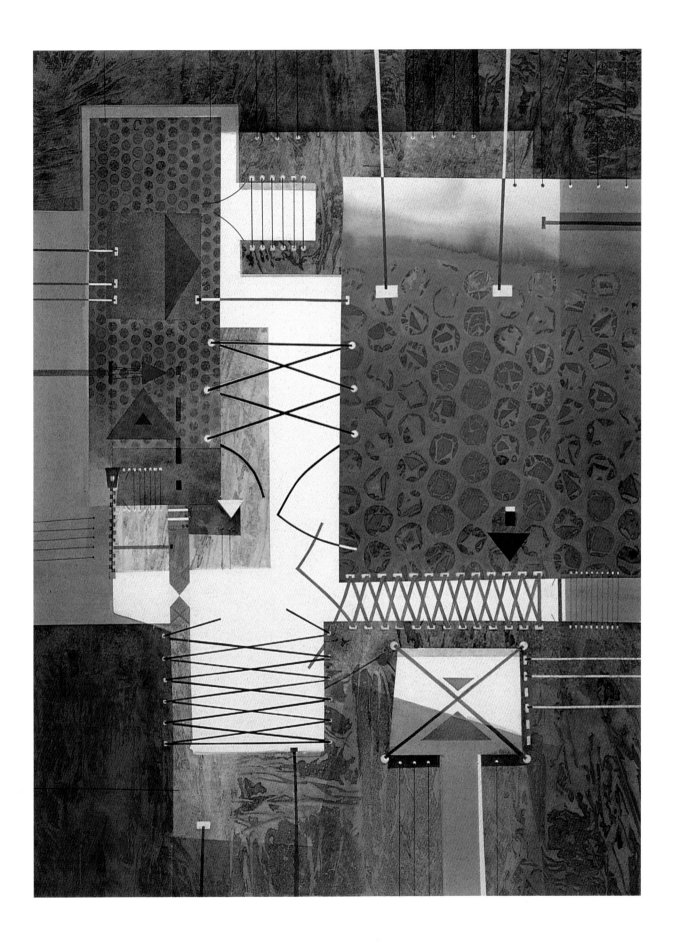

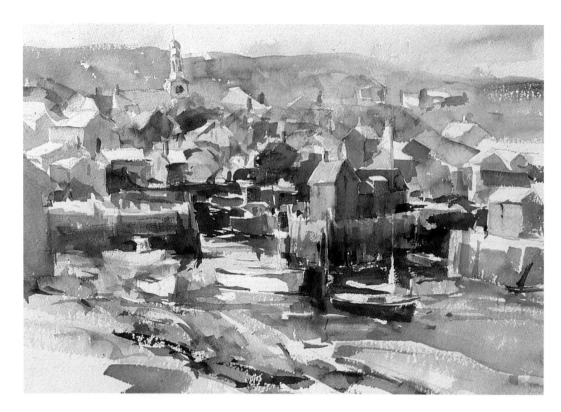

MARILYN SWIFT
Sandy Bay Harbor

11" × 15" (28 cm × 38 cm)
Arches 300 lb. rough
Watercolor and gouache

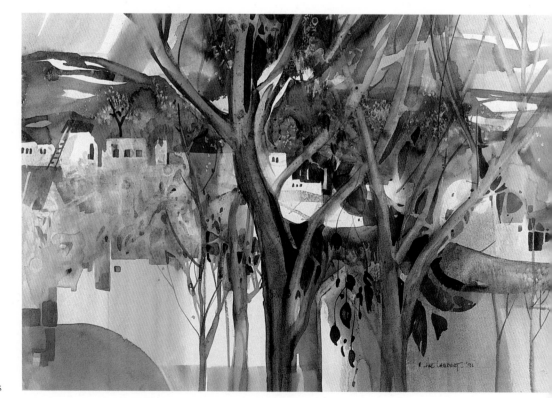

HAL LAMBERT
Tree Series

22" × 30" (56 cm × 76 cm)
Bockingford 140 lb. cold press

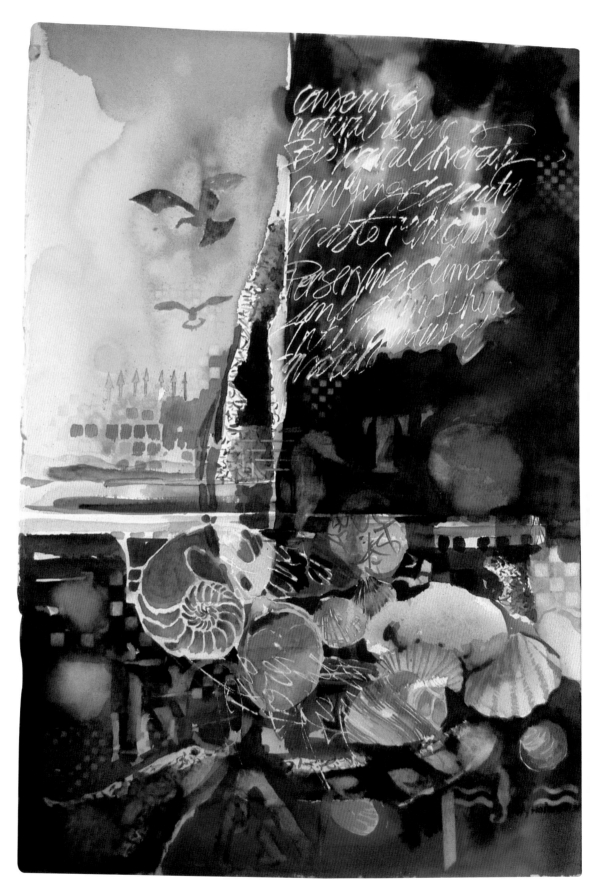

JUDY HOINESS

Land and Sea Series:
Save Our Fish III

30" × 22" (76 cm × 56 cm)
300 lb. cold press

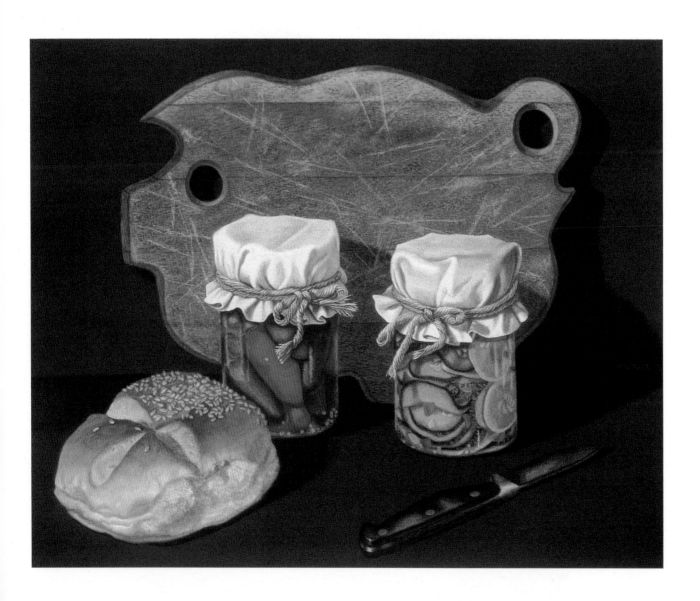

JANIS THEODORE
Pickles, Peppers, and Piggy
11" × 14" (28 cm × 36 cm)
Fabriano 300 lb. watercolor
Watercolor and gouache

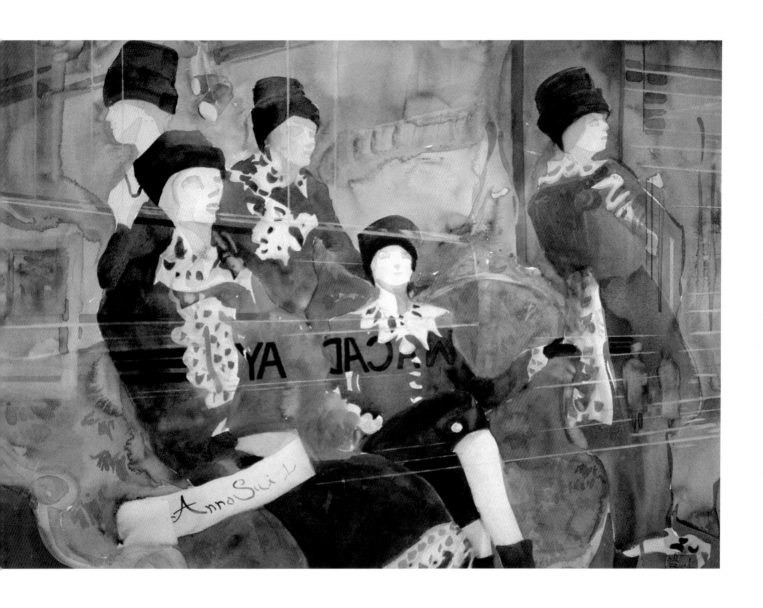

NEL DORN BYRD
On 5th Avenue

22" × 30" (56 cm × 76 cm)
Arches 140 lb. cold press

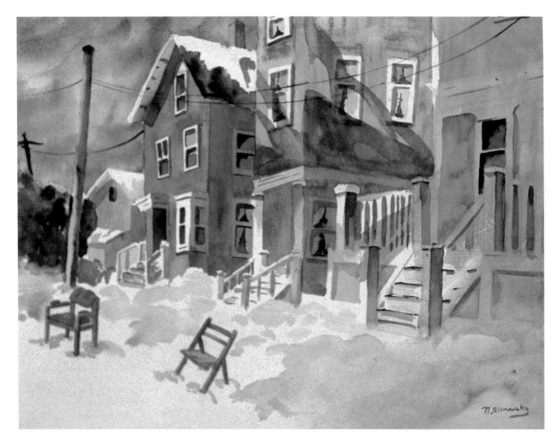

NANCY S. ALIMANSKY
Reserved Parking—Boston Style
24" × 30" (61 cm × 76 cm)
140 lb. rough

PAULA TEMPLE
The Last of the Honeysuckle
40" × 30" (102 cm × 76 cm)
Strathmore watercolor board
cold press
Watercolor and
watercolor crayon
(opposite)

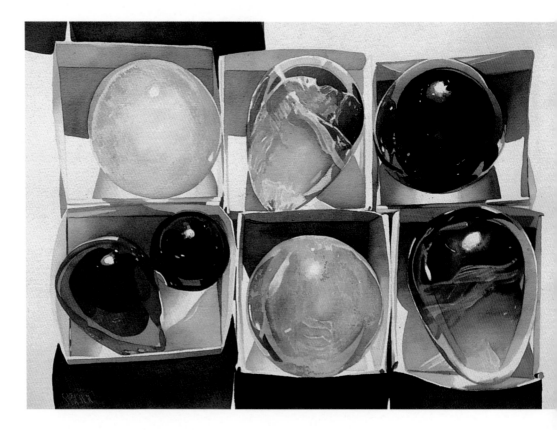

SUSANNA SPANN
Crystals in Containers
30" × 40" (76 cm × 102 cm)
Arches 300 lb.

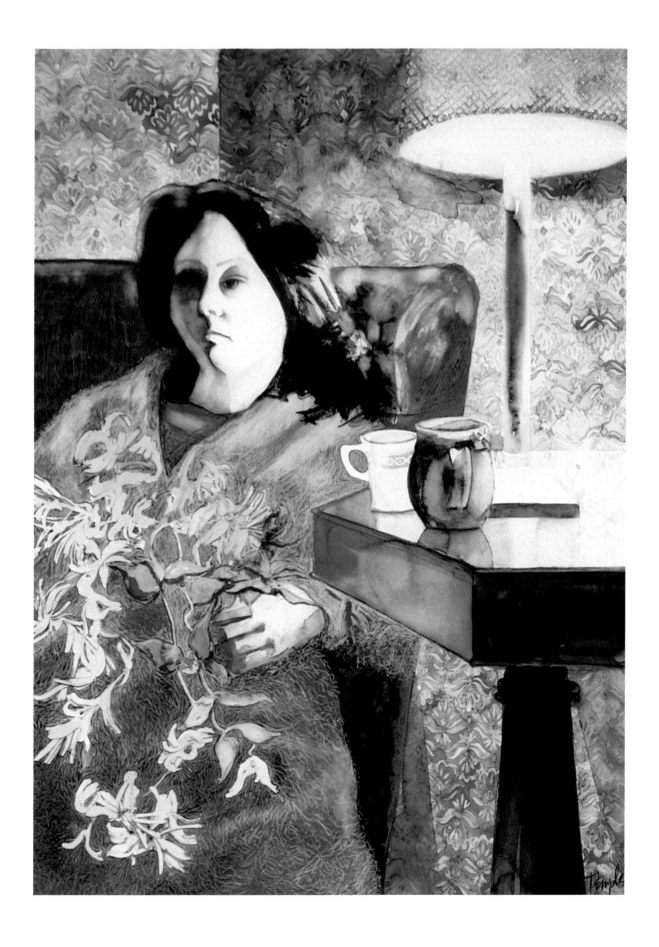

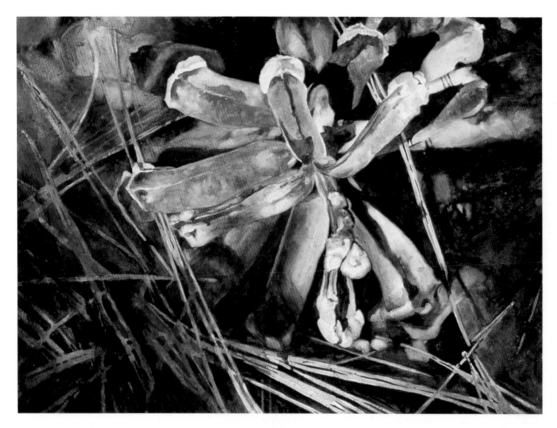

ANGELA BRADBURN
Chiaroscuro
21" × 29" (53 cm × 74 cm)
Arches 140 lb. hot press

ELLNA GOODRUM
Ritual Dance
36" × 28" (91 cm × 71 cm)
Arches 140 lb. cold press
(opposite)

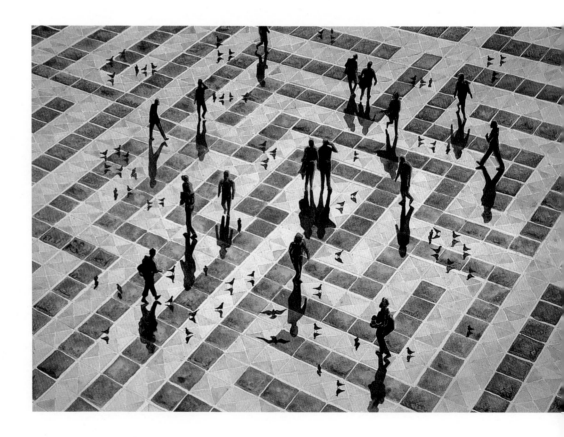

LAUREL COVINGTON-
VOGL
Walking the Maze
25" × 32" (64 cm × 81 cm)
140 lb. cold press

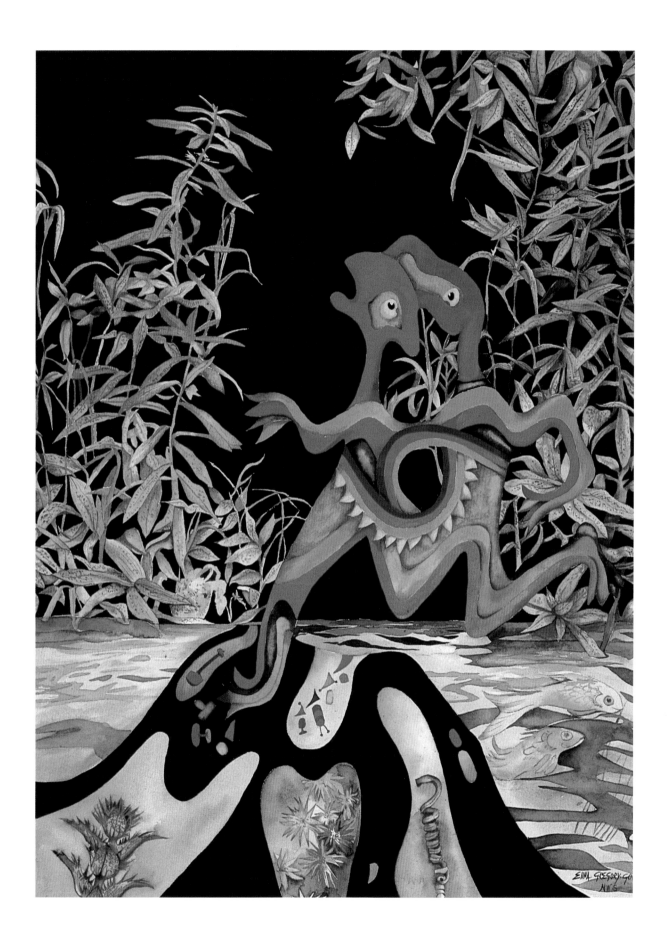

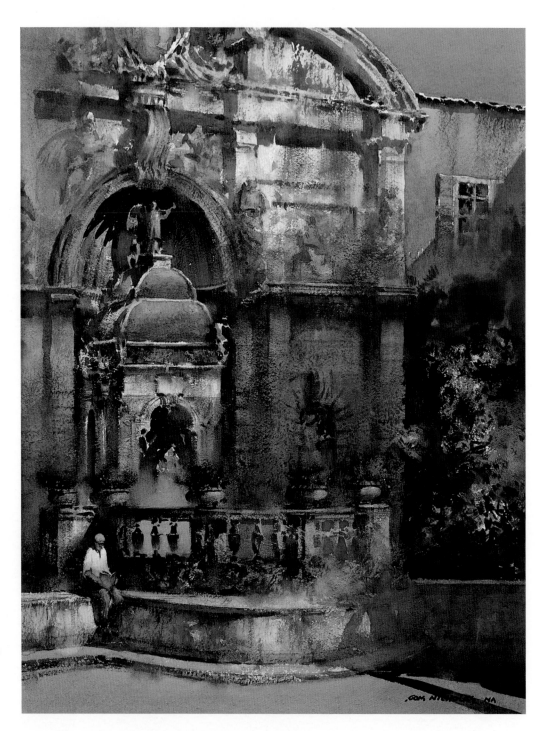

TOM NICHOLAS
Fountain at Tivoli, Italy
24" × 18" (61 cm × 46 cm)
Fabriano

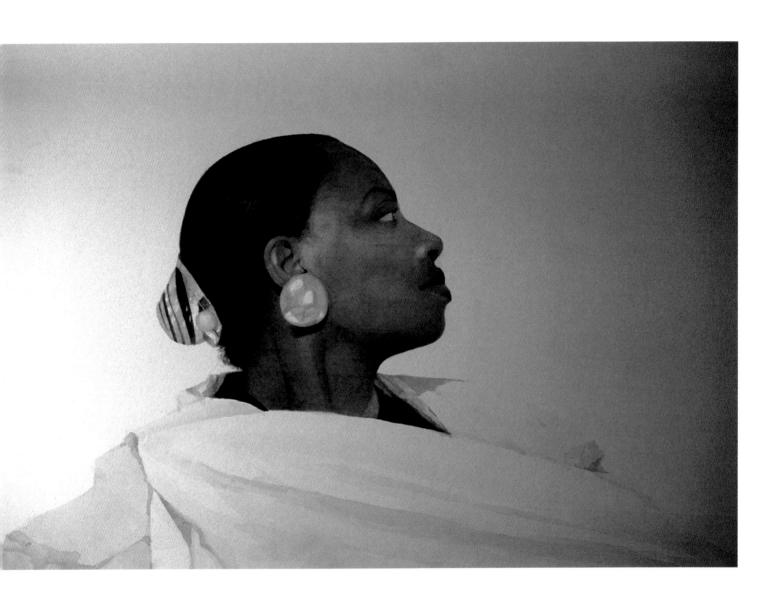

DEAN MITCHELL
Carolyn
20" × 30" (51 cm × 76 cm)
Crescent watercolor board
hot press

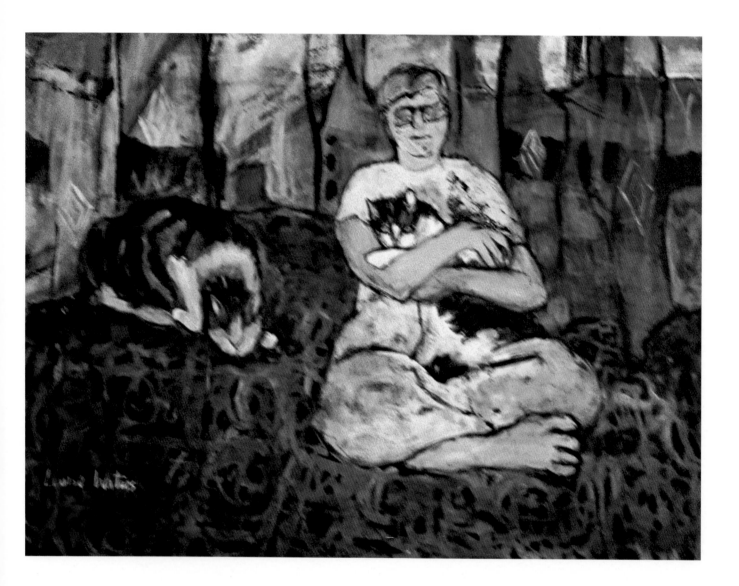

LOUISE WATERS
Rug Cats
32" × 40" (81 cm × 102 cm)
Strathmore 4-ply mounting
board
Watercolor and acrylic

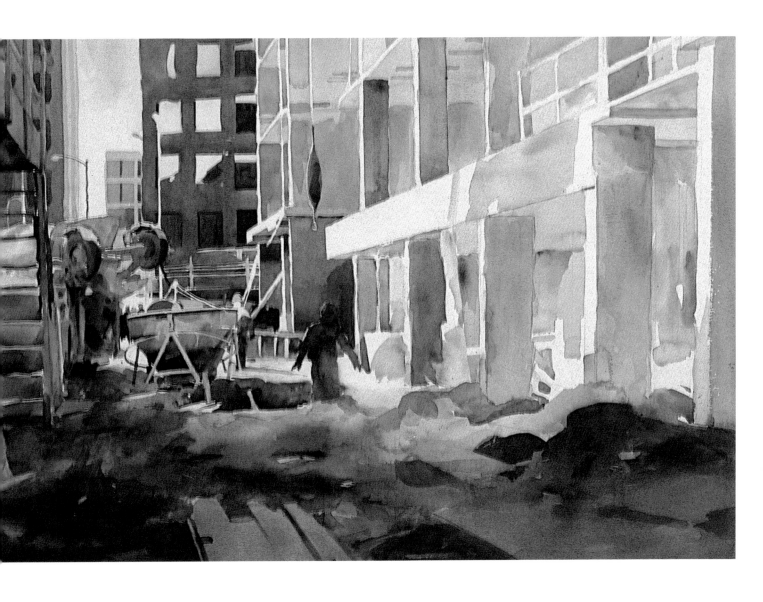

TOM FRANCESCONI
Pumpkin Patch

13.5" × 20.5" (34 cm × 52 cm)
Winsor & Newton watercolor
paper 140 lb. cold press

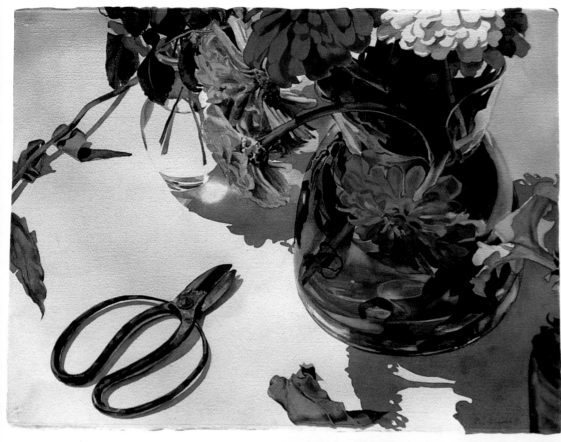

KAY HOPPOCK
Garden Flowers in Glass
22" × 30" (56 cm × 76 cm)
Arches 300 lb. cold press

PAUL W. MCCORMACK
Hope
27" × 17" (69 cm × 43 cm)
Arches 140 lb. cold press
(opposite)

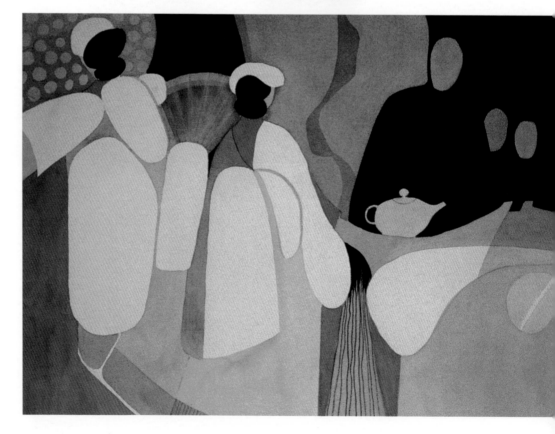

MARJEAN WILLETT
Two Geishas
22" × 30" (56 cm × 76 cm)
Arches 300 lb. cold press

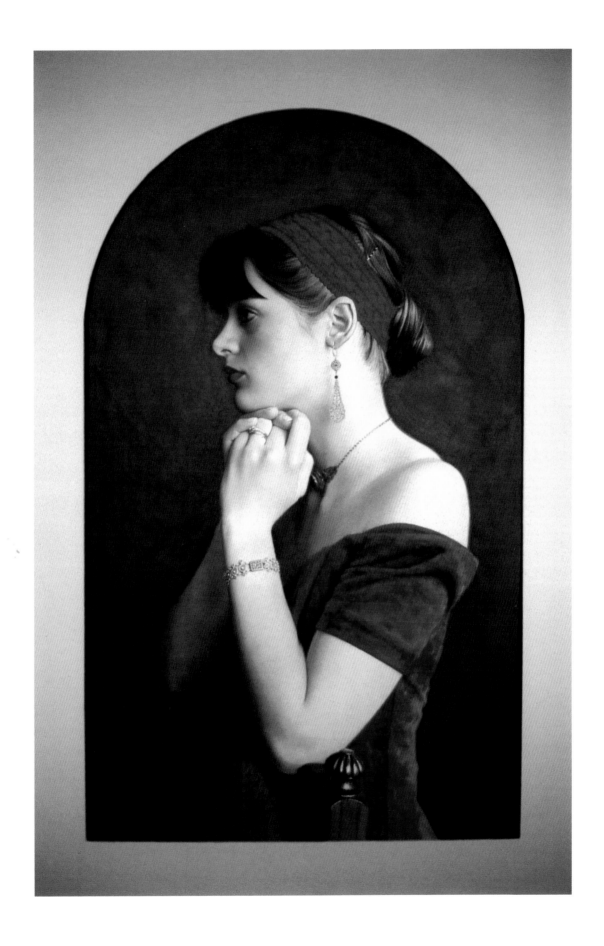

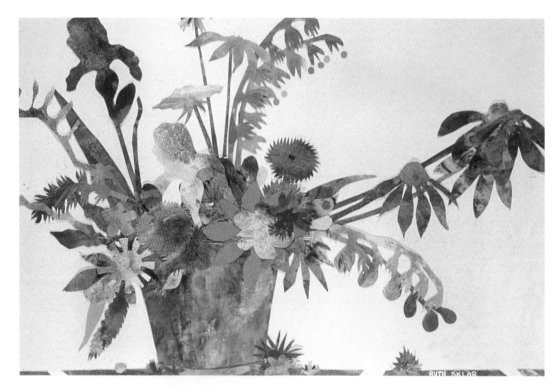

RUTH SKLAR
A Mixed Bouquet

14" × 21.5" (36 cm × 55 cm)
Arches 140 lb. cold press
Watercolor and acrylic

PAT TRUZZI
Cousins

10" × 7" (25 cm × 18 cm)
Lanaquarelle 140 lb. cold press
(opposite)

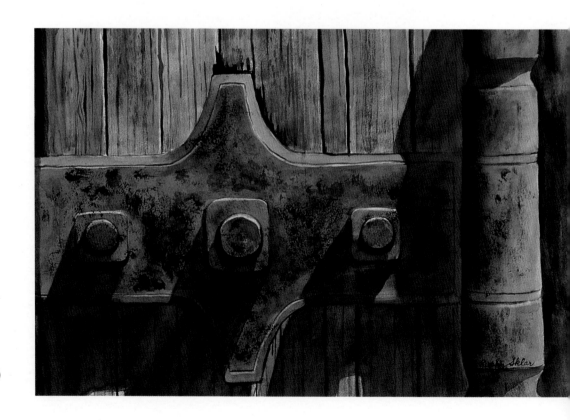

RUTH SKLAR
Scotty's Gate

15" × 22" (38 cm × 56 cm)
Arches 140 lb. cold press

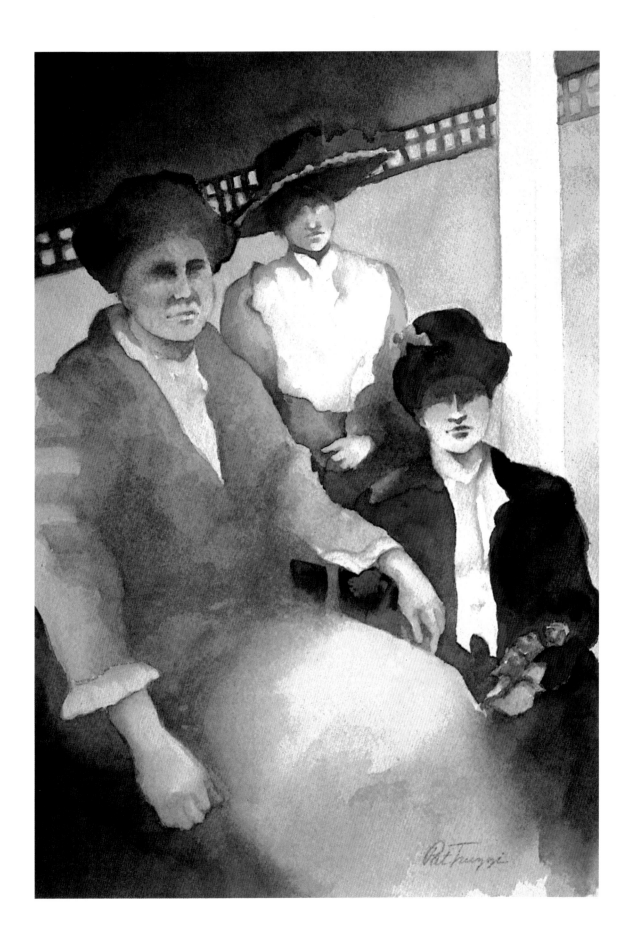

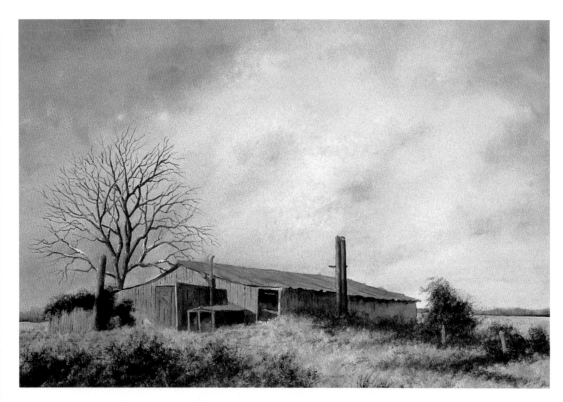

FLOYD SPECK
Shedding a Little Light on the Subject

21" × 29" (53 cm × 74 cm)
Arches 140 lb. cold press

ANNE VAN BLARCOM
KUROWSKI
Navy Blue

21" × 14" (53 cm × 36 cm)
Arches 140 lb.
(opposite)

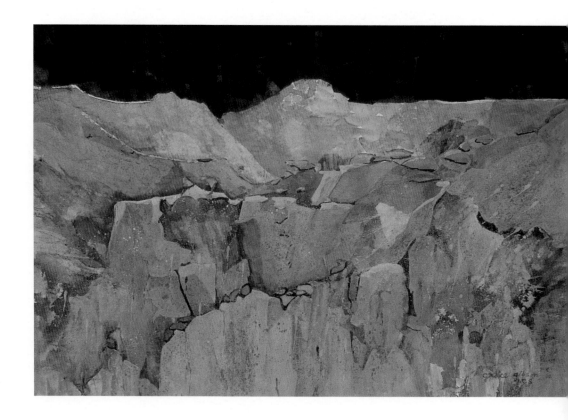

BETTY GRACE GIBSON
Thunder Mountain

21" × 29" (53 cm × 74 cm)
Aquarius watercolor paper
Watercolor and gouache

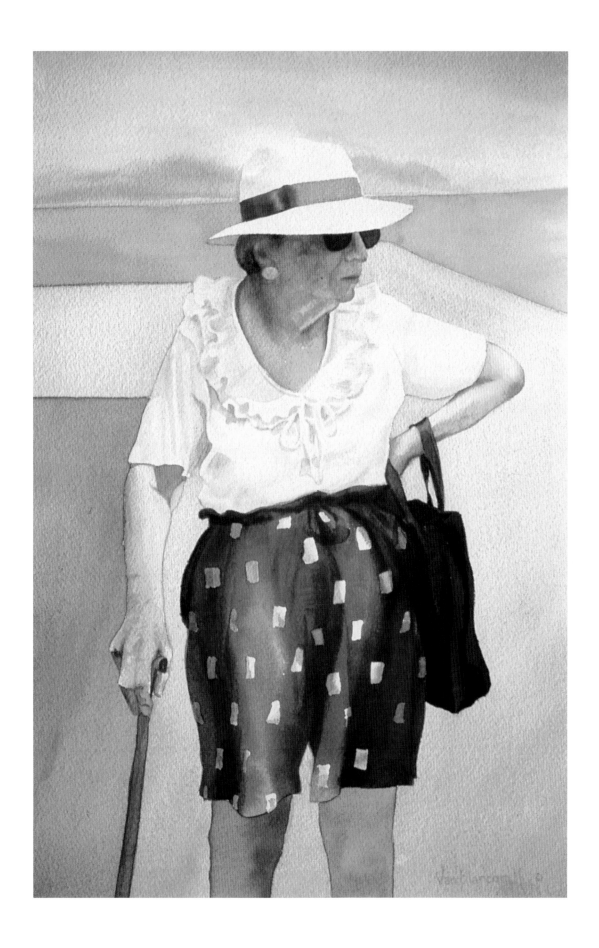

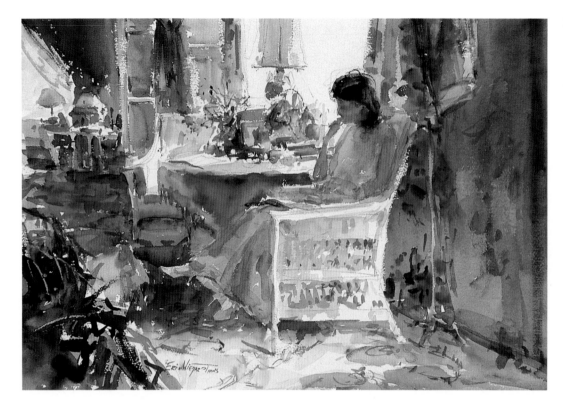

ERIC WIEGARDT
The Novel

19" × 25" (48 cm × 64 cm)
Arches 140 lb. cold press

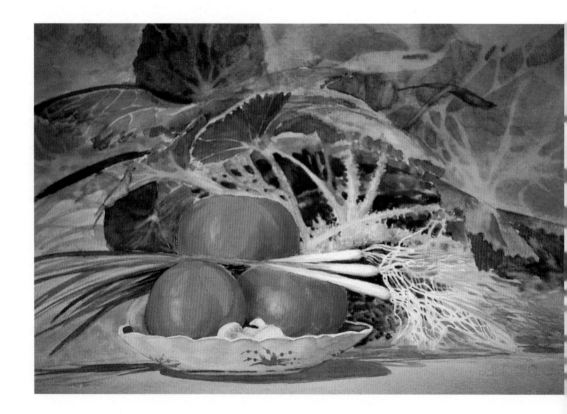

DEBBIE TINTLE
Still Life

16" × 20" (41 cm × 51 cm)
Arches 140 lb. cold press

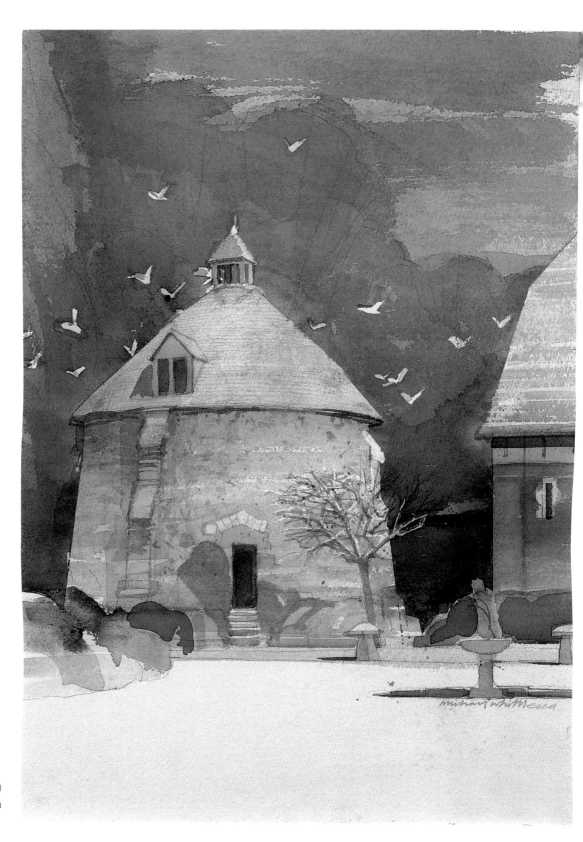

MICHAEL WHITTLESEA
Dovecote in Winter
22.5" × 16" (57 cm × 41 cm)
Aquarelle Arches 90 lb. rough

111

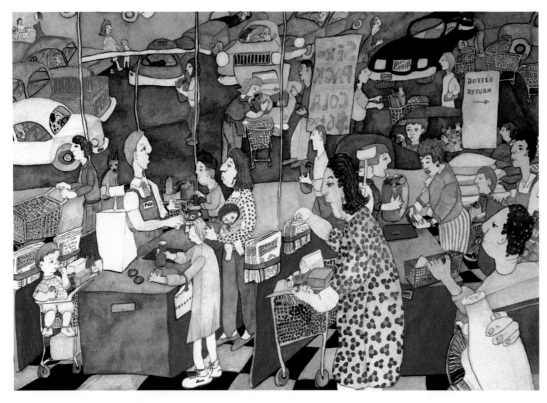

J. Elizabeth Santone
Checkers

19" × 27" (48 cm × 69 cm)
100% rag 140 lb. cold press

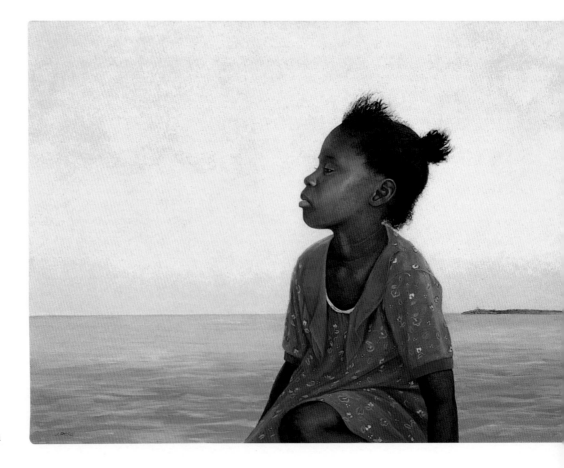

Jerry Rose
Victory

18" × 24" (46 cm × 61 cm)
Gessoed panel
Watercolor and egg tempera

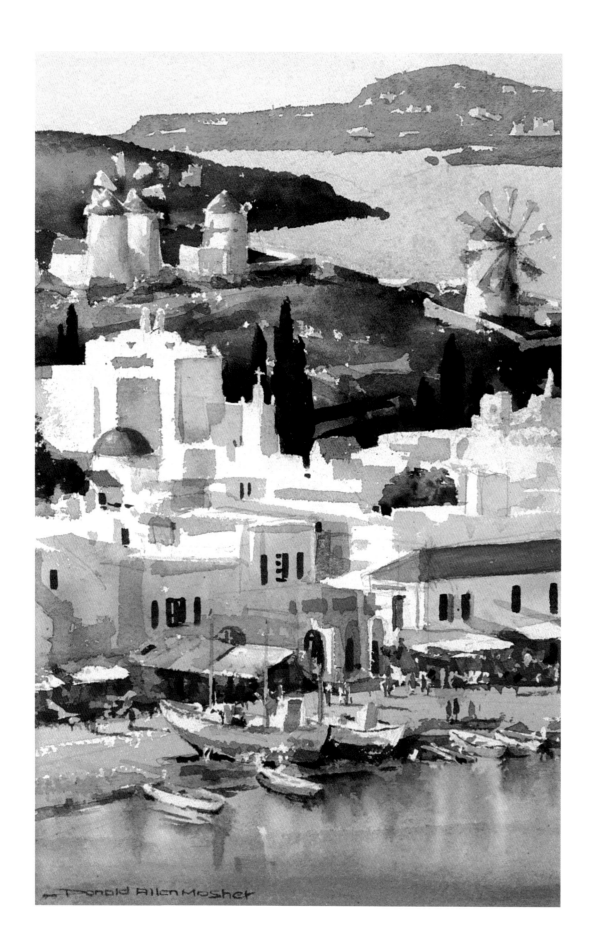

DONALD A. MOSHER
Mykonos, Greece
9" × 6" (23 cm × 15 cm)
Fabriano 140 lb.

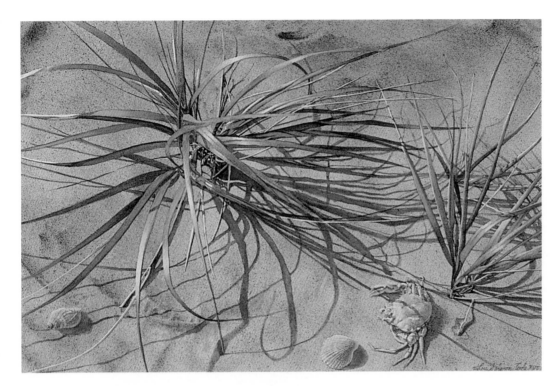

LOIS SALMON TOOLE
Circle of Friends
13.5" × 21" (34 cm × 53 cm)
100% rag 300 lb. cold press

DONNA ZAGOTTA
Life Stories
30" × 22" (76 cm × 56 cm)
Lanaquarelle 140 lb. hot press
Watercolor, goauche, and
Caran D'Ache crayons
(opposite)

MARY BLACKEY
Force in Passage
26" × 40" (66 cm × 102 cm)
Arches 300 lb. cold press
Watercolor and acrylic

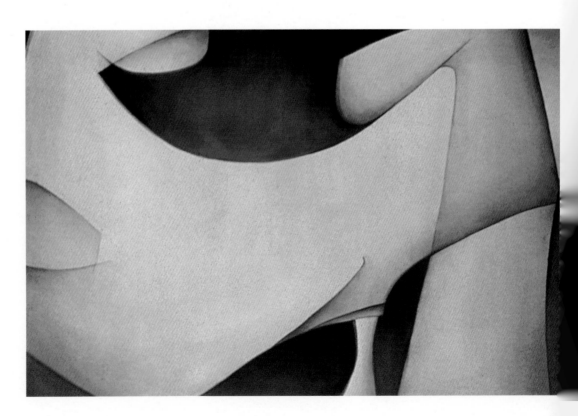

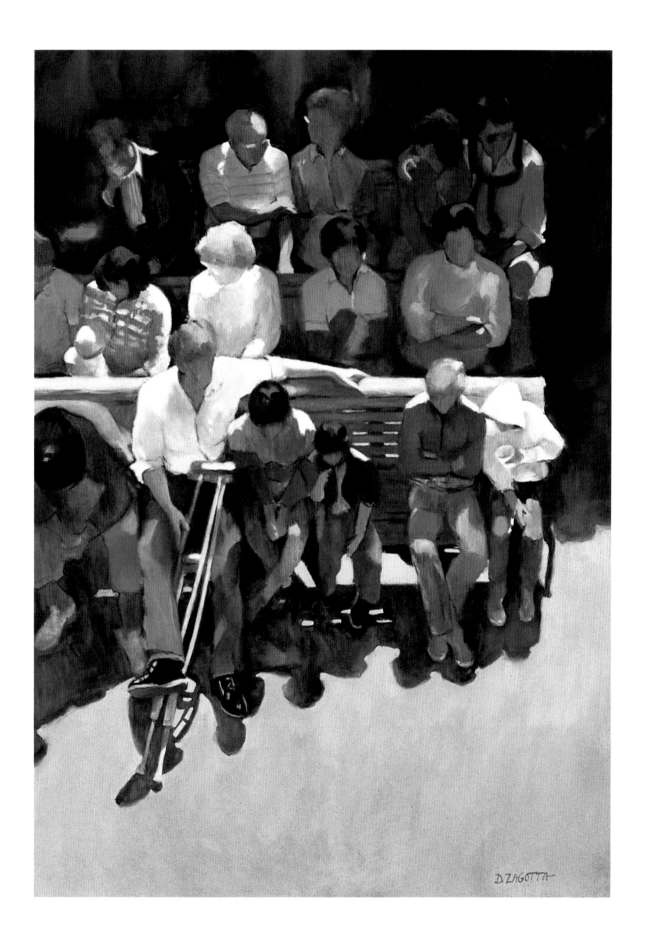

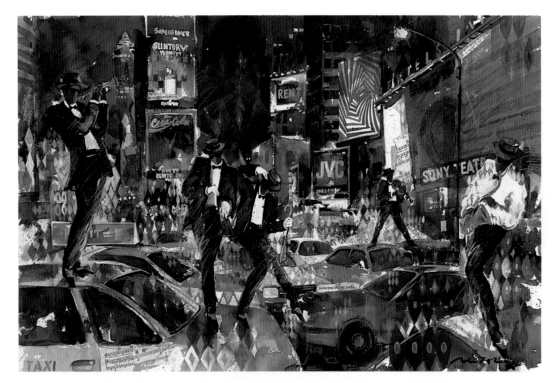

MISHA LENN
La Fete de la Musique
24" × 36" (61 cm × 91 cm)
Arches 140 lb. cold press
Watercolor and color pencils

MERWIN ALTFELD
Artist Working
27" × 27" (69 cm × 69 cm)
Arches 300 lb. cold press
Watercolor and acrylic
(opposite)

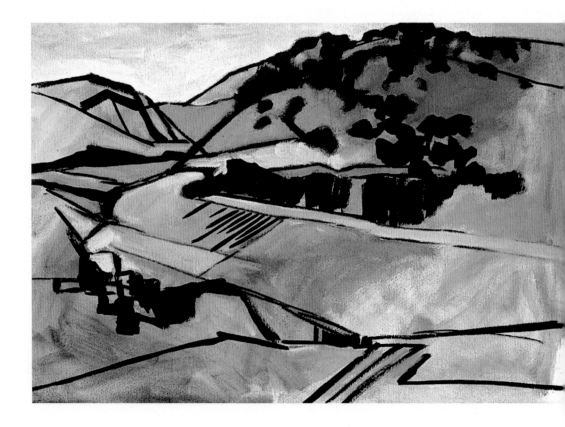

BARBARA MILLICAN
Foothills
22" × 30" (56 cm × 76 cm)
140 lb. cold press
Watercolor, acrylic, and ink

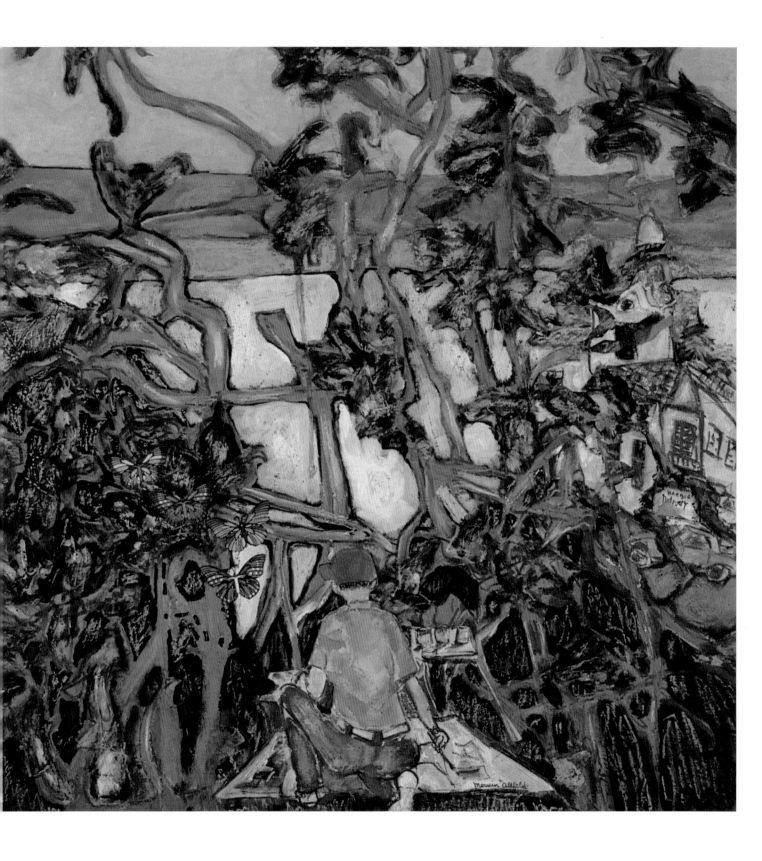

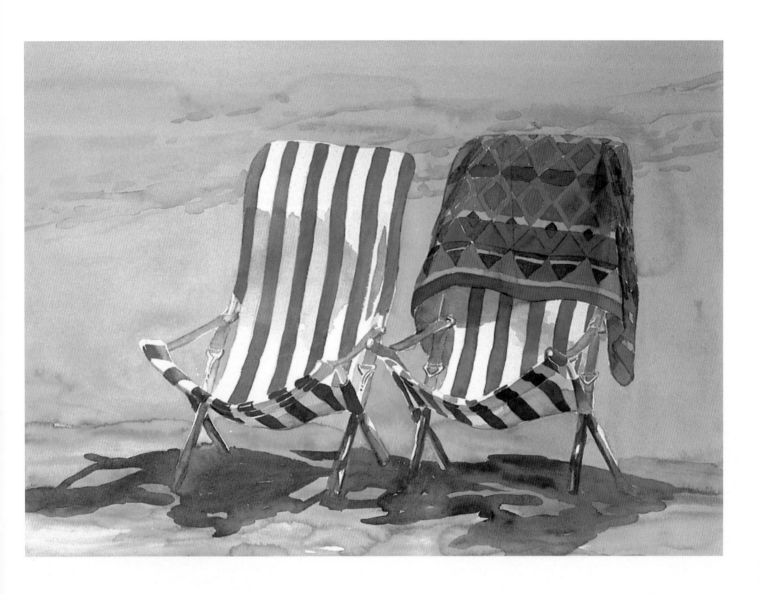

MAE A. VAN ARK

Beachside Comfort

22" × 30" (56 cm × 76 cm)
Arches 300 lb. cold press

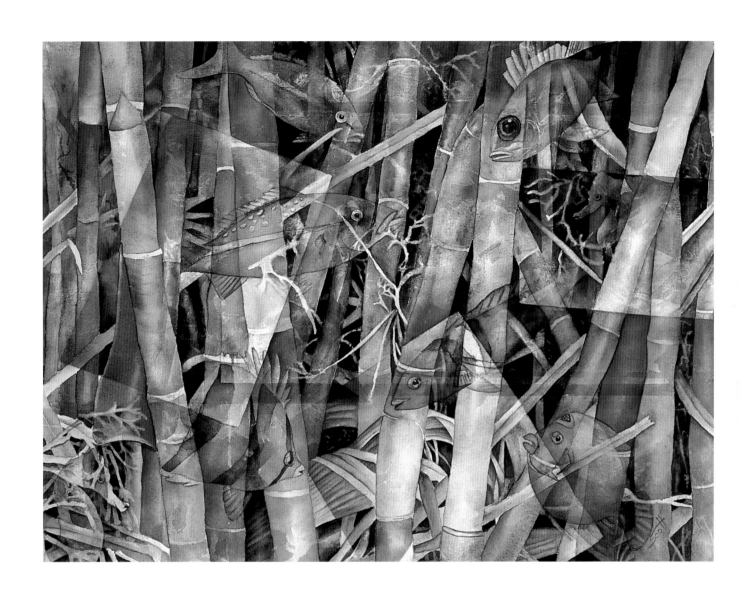

C. Patricia Scott
Fish 'n Poles

22" × 30" (56 cm × 76 cm)
Arches 140 lb. cold press
Watercolor and underpainting
with gesso

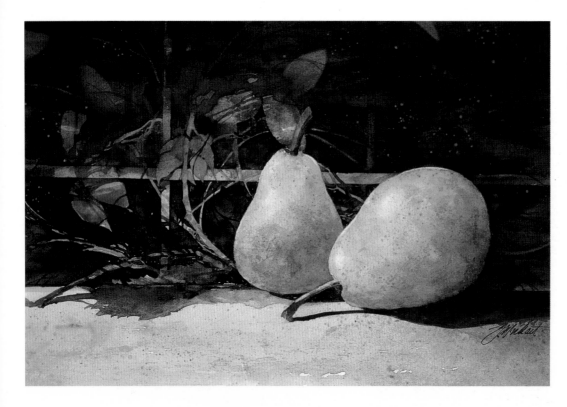

TERRY WICKART
Pair of Pears
11" × 17" (28 cm × 43 cm)
Fabriano Artistico 140 lb.

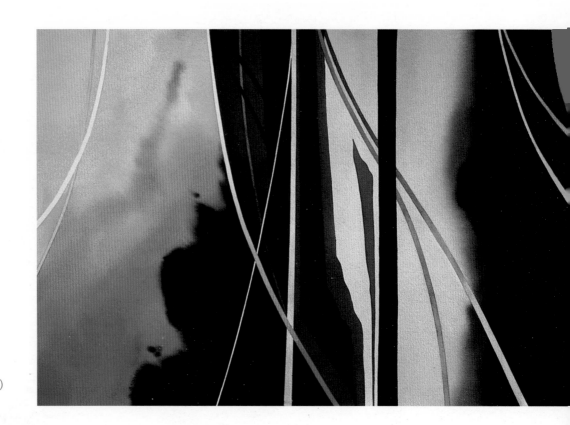

BARBARA SCULLIN
Untamed Nature
20" × 30" (51 cm × 76 cm)
Arches 300 lb.

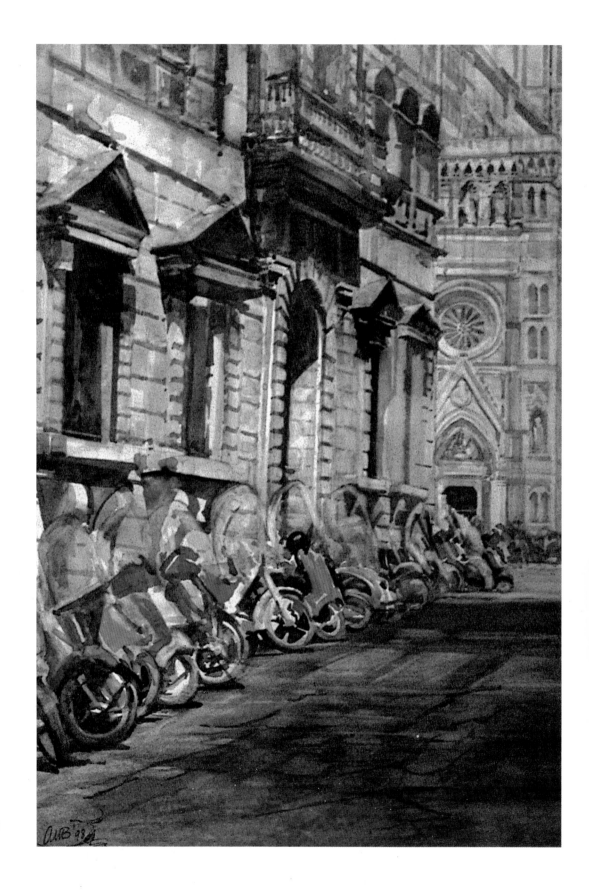

ANN M. BANNISTER

When in Florence

20" × 14" (51 cm × 36 cm)
Gemini 140 lb. hot press

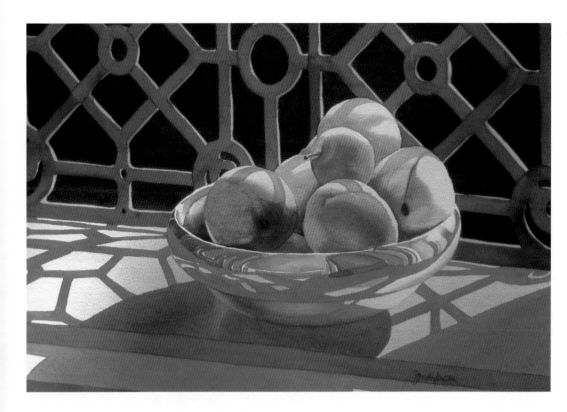

JUDY BATES
Moonlight and Fruit
16" × 24" (41 cm × 61 cm)
300 lb. cold press

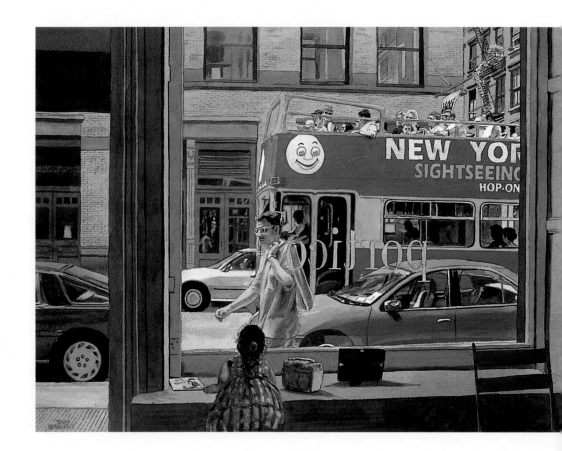

RUTH NEWQUIST
Hop On
21" × 29" (53 cm × 74 cm)
Arches 300 lb. cold press

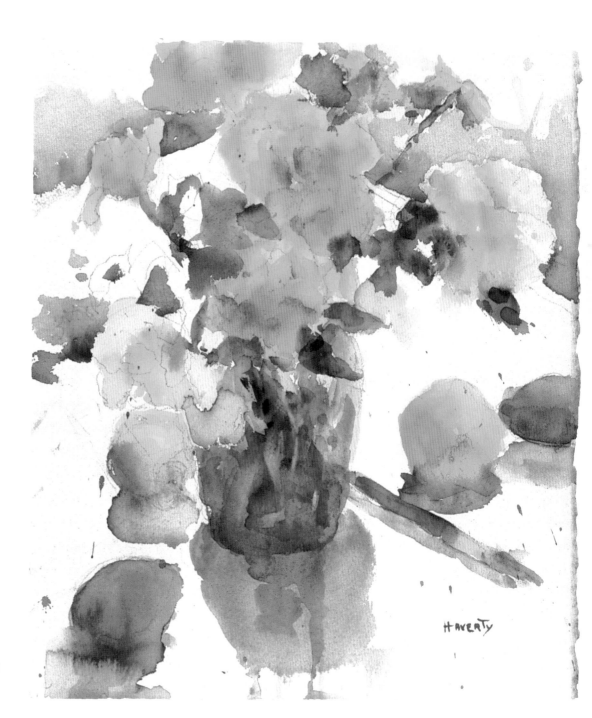

GRACE L. HAVERTY
Peonies and Paintbrush

15" × 11" (38 cm × 28 cm)
Arches 140 lb. cold press

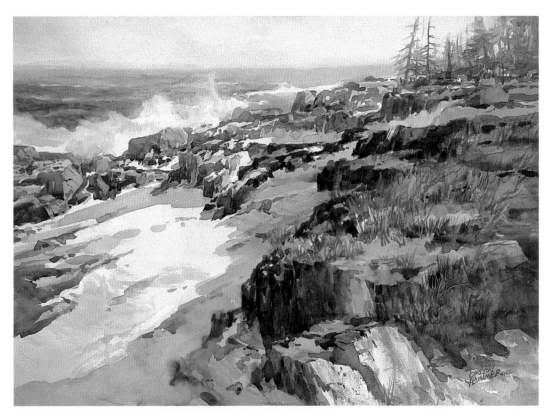

CARLTON PLUMMER
Winter Island

22" × 30" (56 cm × 76 cm)
Waterford Series 140 lb.
cold press

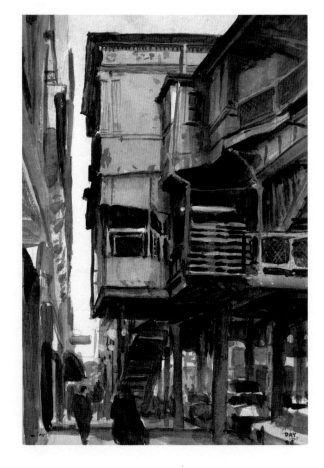

LARRY DAY
Chicago El Station

14" × 9.5" (36 cm × 24 cm)
Twinrocker handmade
watercolor paper
Watercolor and gouache

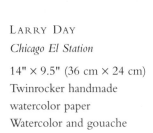

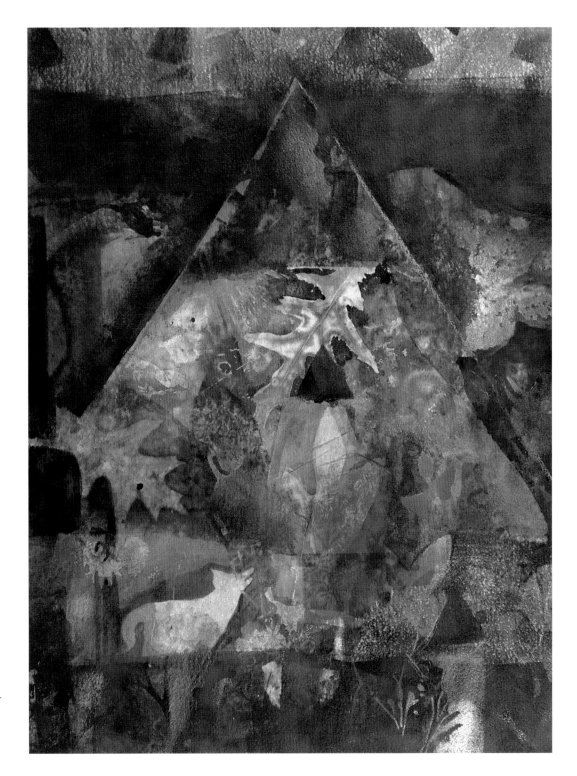

LYNNE KROLL
Legacy

30" × 22" (76 cm × 56 cm)
Arches 140 lb. cold press
Watercolor, acrylic, gouache,
watercolor pencils, watercolor
crayons, metallic acrylics, and
interference gold and pearl
acrylic

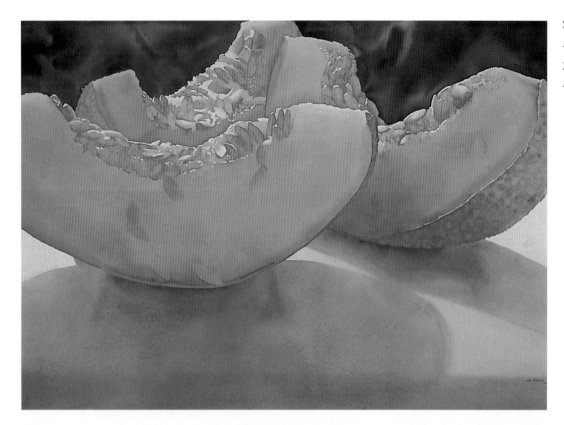

SUE ARCHER
Melon-Colony 4
29" × 41" (74 cm × 104 cm)
Arches Double Elephant paper

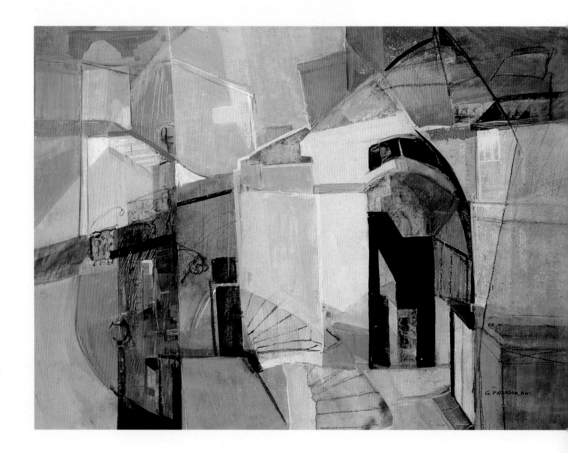

GLORIA PATERSON
New World—Old City
22" × 30" (56 cm × 76 cm)
Arches 300 lb. cold press
Watercolor, acrylic, crayon,
and acrylic markers

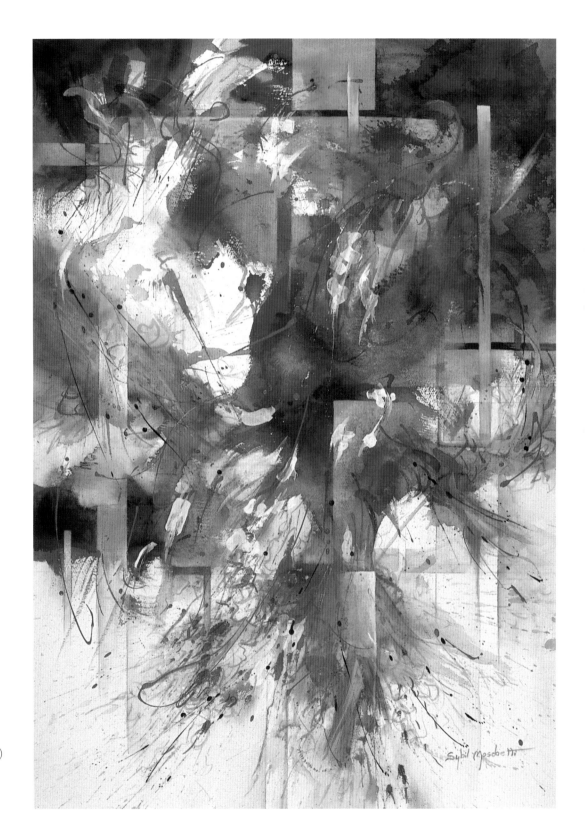

SYBIL I. MOSCHETTI
Breakup

42" × 30" (107 cm × 76 cm)
Arches 300 lb. rough
Watercolor, acrylic, and
gouache

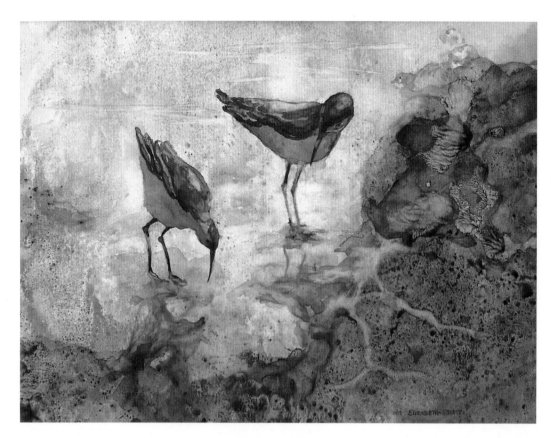

ELIZABETH PRATT
Water's Edge

23" × 28" (58 cm × 71 cm)
Strathmore Series 3-ply medium
surface 500 lb. hot press

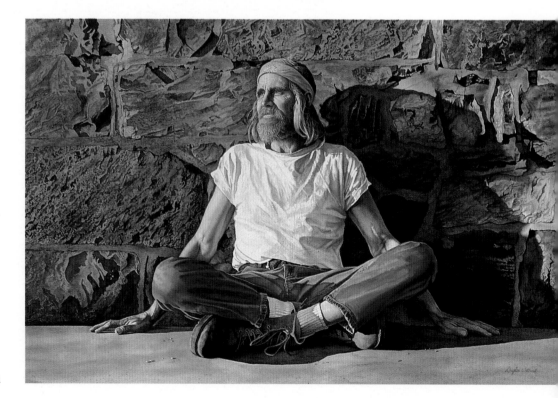

DOUGLAS WILTRAUT
Monk

38" × 58" (97 cm × 147 cm)
Arches Triple Elephant rough

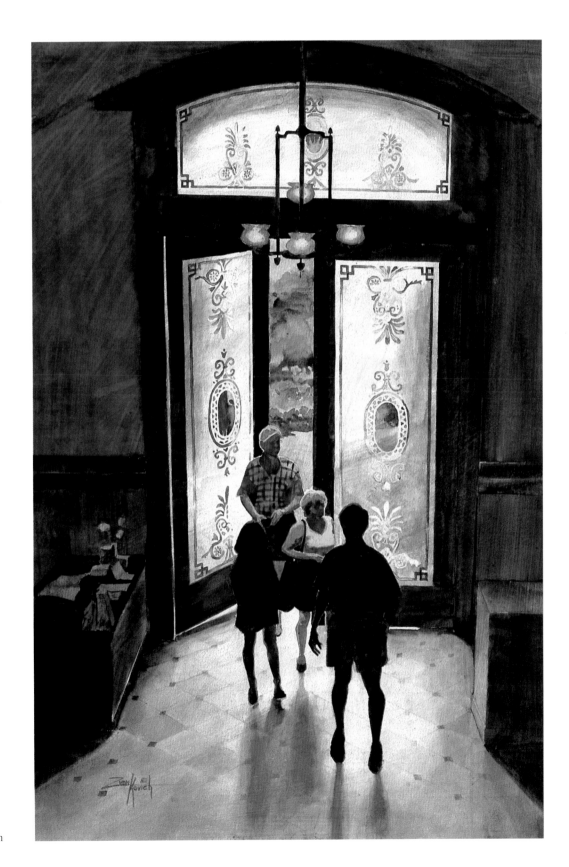

MARIYA K. ZVONKOVICH
Entering the Renwick

28" × 20" (71 cm × 51 cm)
300 lb. paper with undercoat
of gesso
Watercolor, gouache, and casein

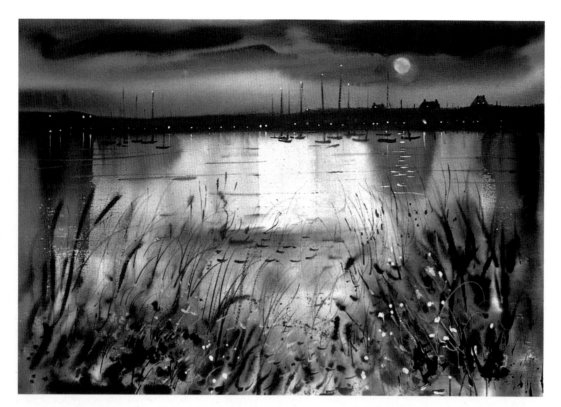

FRED L. MESSERSMITH
Moon Shadows

22" × 30" (56 cm × 76 cm)
Arches 300 lb. cold press
Watercolor with gouache

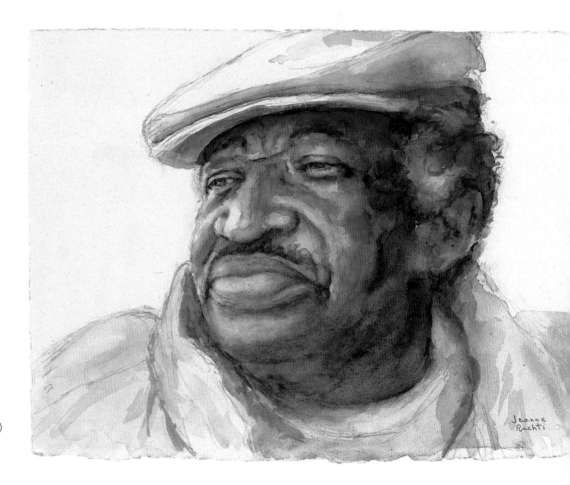

JEANNE A. RUCHTI
Willie

11" × 15" (28 cm × 38 cm)
Arches 300 lb. cold press

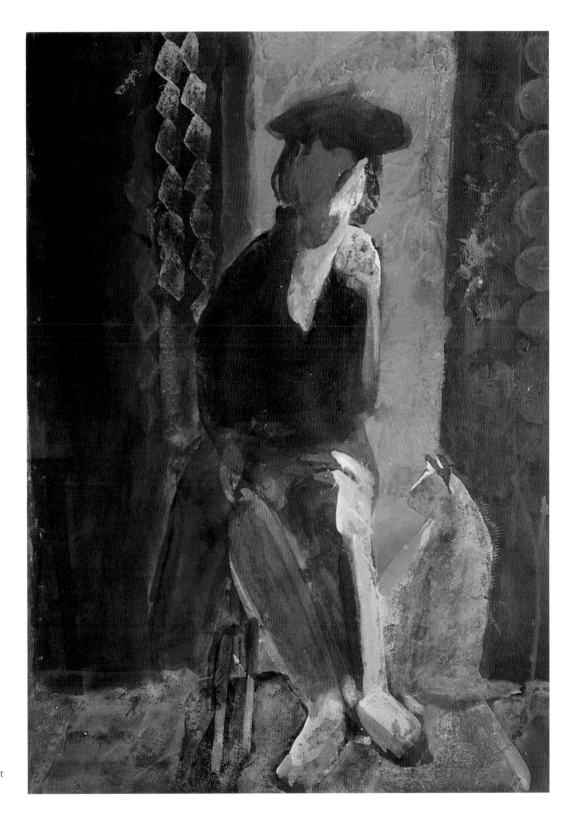

SANTO PEZZUTTI
Girl with Beret
30" × 22" (76 cm × 56 cm)
Watercolor, layered transparent
washes, and acrylic

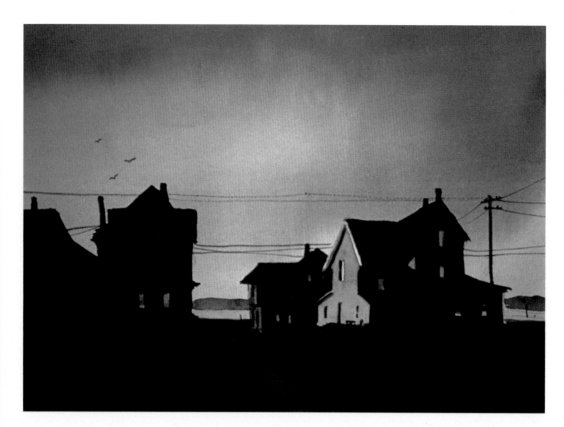

MARGARET GRAHAM KRANKING
Evening Glow, Chincoteague
7" × 10" (18 cm × 25 cm)
Arches 140 lb. cold press
Watercolor, Grumbacher,
and Holbein

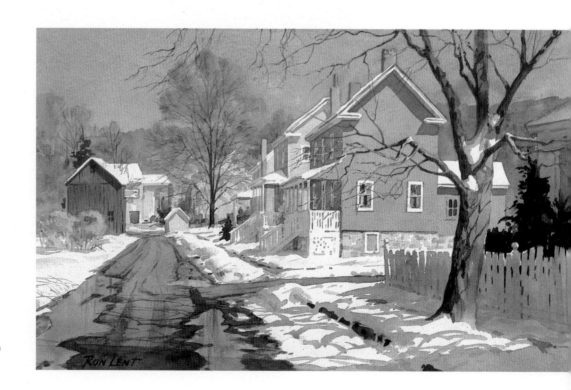

RON LENT
Melting Off
22" × 31" (56 cm × 79 cm)
Arches 140 lb. rough

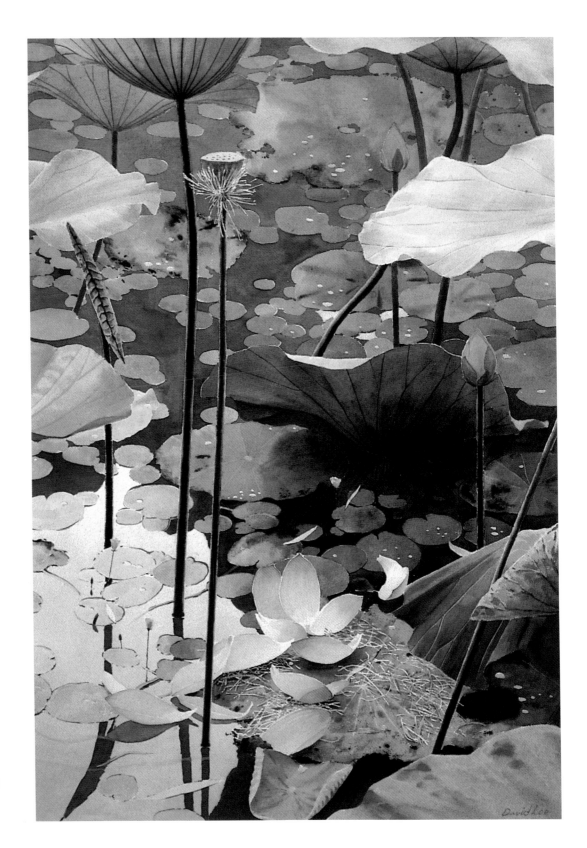

DAVID T. LEE
Lotus Pond
39" × 29" (99 cm × 74 cm)
Arches 300 lb. watercolor
paper

133

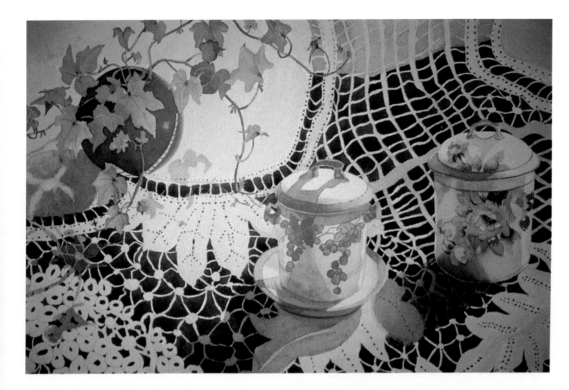

GIFFIN RUSSELL
The Jelly Jars
15" × 22" (38 cm × 56 cm)
Arches 140 lb. cold press

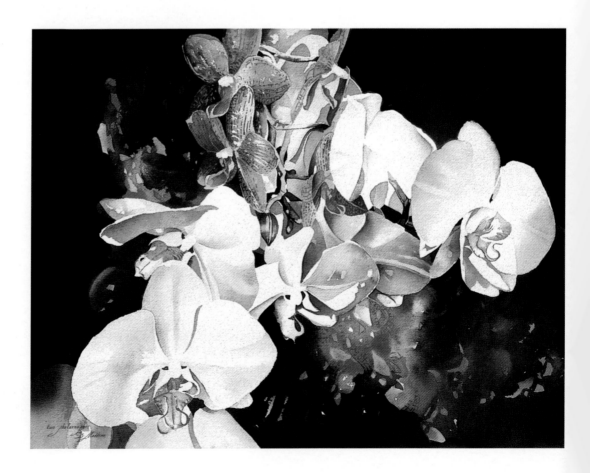

DAVID MADDERN
Two Phalaenopsis
23" × 30" (58 cm × 76 cm)
Arches 300 lb. cold press

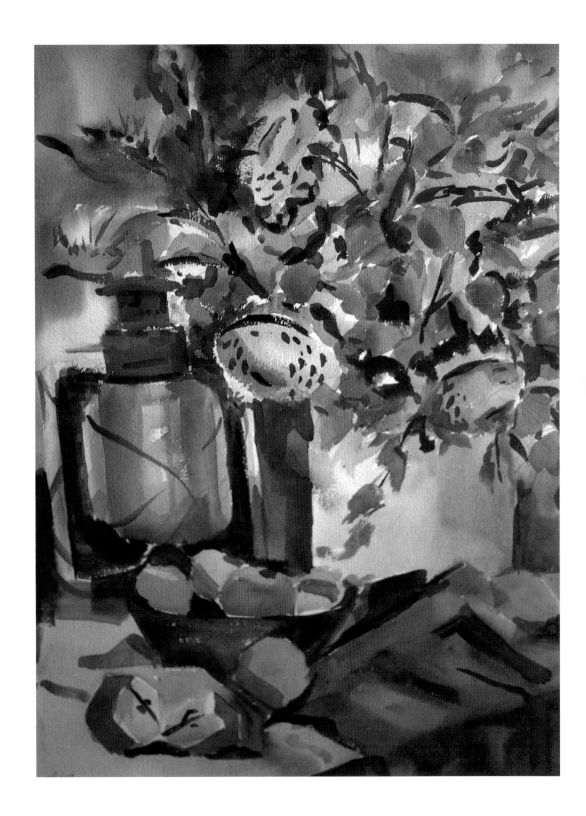

CHRISTINE A. PITMAN
Autumn Still Life
25" × 20" (64 cm × 51 cm)
Arches 260 lb. cold press

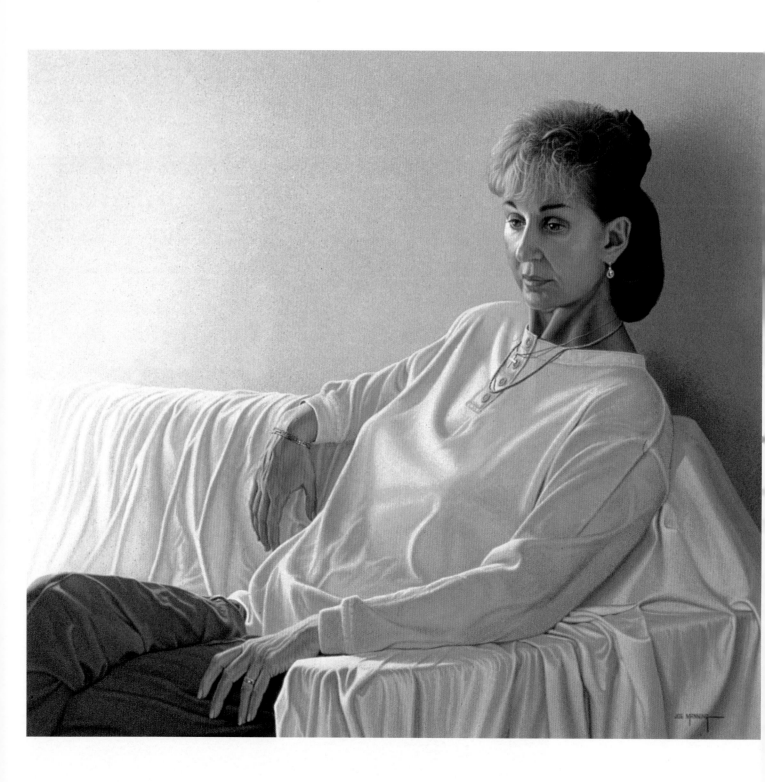

JOE MANNING

The Light of My Life

27.5" × 29.5" (70 cm × 75 cm)
Arches 140 lb. hot press
Watercolor and egg tempera

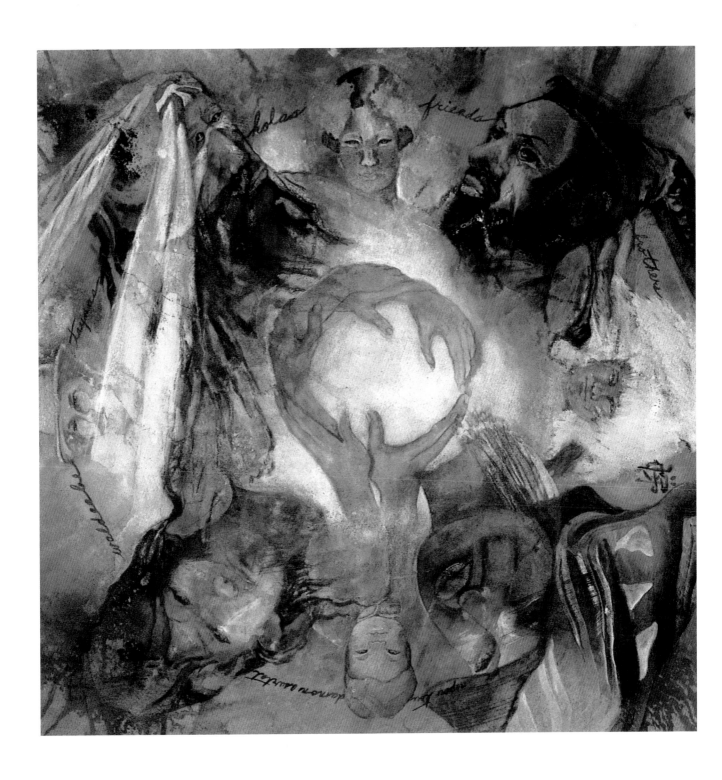

MURIEL S. COOK
Circle of Life

22" × 22" (55 cm × 55 cm)
Strathmore Aquarius II
Watercolor, gouache, and gesso

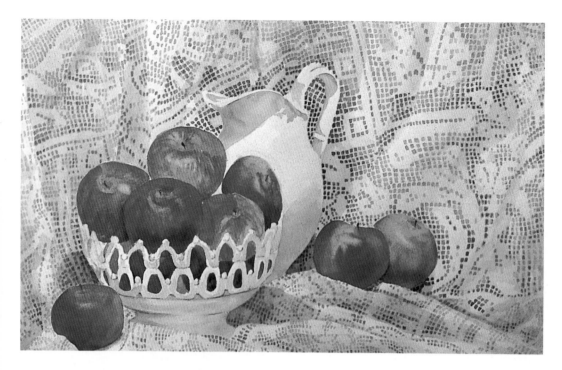

MARION SWIERKOS
Apples and Lace
20.5" × 27.5" (52 cm × 70 cm)
Arches 140 lb. cold press

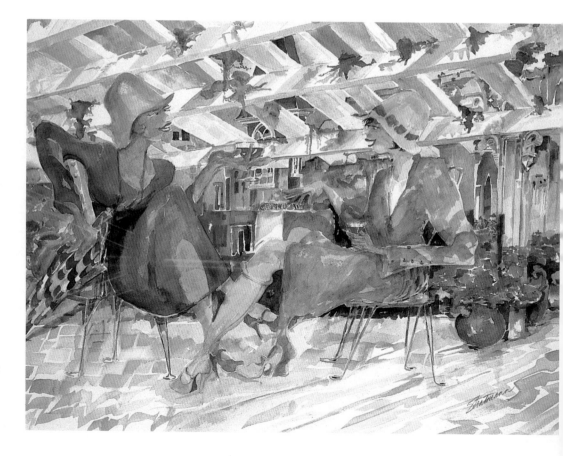

CHARLES I. STRATMANN
The Pergola
30" × 38" (76 cm × 97 cm)
Fabriano Uno 260 lb.

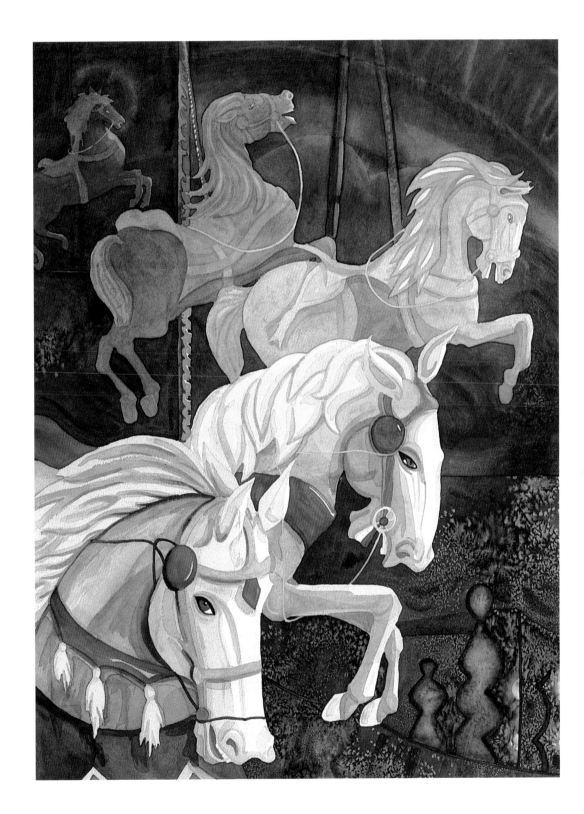

JOANNE L. HATCH
Get On

29" × 21" (74 cm × 53 cm)
Arches 140 lb. cold press
Watercolor and opaque
watercolor

JUDGES

SERGE HOLLERBACH, N.A., A.W.S., D.F., was born in Detskoye Selo (Tzarskoye), Russia in 1923. He studied at the Munich Academie of Fine Arts, Munich, West Germany from 1946 to 1949 and continued his studies in America at the Art Students League in New York City in 1951.

Mr. Hollerbach is a member of the National Academy of Design (Academician), the American Watercolor Society, and is a member of the Dolphin Fellowship and an honorary president of the American Watercolor Society. A member of the Allied Artists and the National Academy of Painters in Casein and Acrylic.

Serge Hollerbach's work is included in many museums throughout the United States and Russia. He can also be found in collections of the Yale University Museum of Art, New Haven, Connecticut; the Thomas Whitney Collection, Washington, CT; the Tretiakov Gallery, Moscow, Russia; the State Russian Museum, Saint Petersburg, Russia; the Voronezh Art Museum, Voronezh Russia; and the New York Public Library.

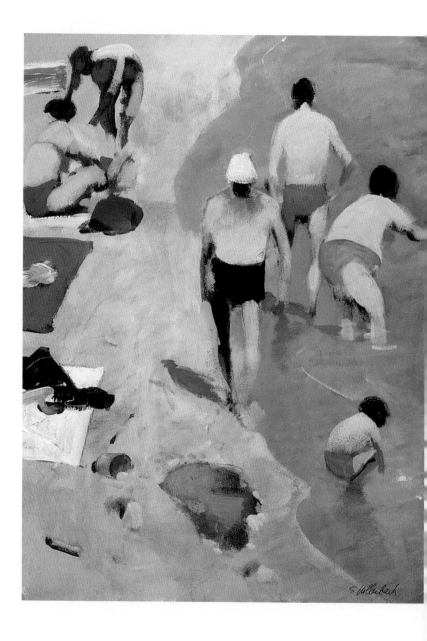

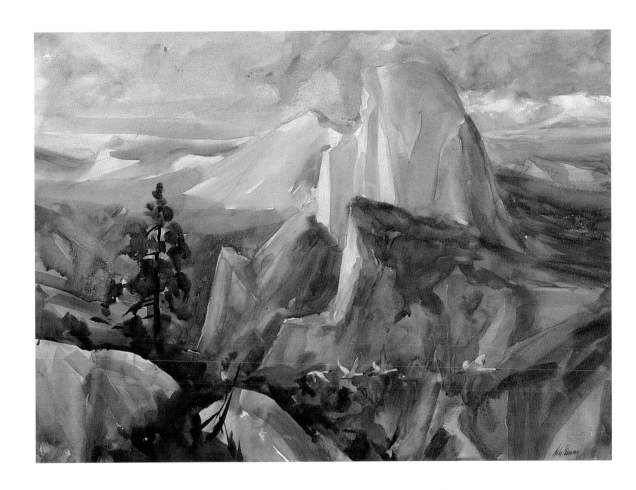

BETTY LOU SCHLEMM, A.W.S., D.F., has been painting for more than forty years. Elected to the American Watercolor Society in 1964, and later elected to the Dolphin Fellowship, she has served as both regional vice-president and director of the American Watercolor Society. Ms. Schlemm is also a teacher and an author. Her painting workshops in Rockport, Massachusetts, have become renowned during the past thirty years. Her book *Painting with Light,* published by Watson-Guptill in 1978, has remained a classic. She also has recently published *Watercolor Secrets for Painting Light,* distributed by North Light Books—F&W Publications, Cincinnati, Ohio.

DIRECTORY/INDEX

Richard K. Hillis 23
6741 West Cholla
Peoria, AZ 85345

Judy Hoiness 93
1840 North West
Vicksburg Avenue
Bend, OR 97701

Serge Hollerbach 140
304 West 75th Street
New York, NY 10023-1609

Kay Hoppock 104
1429 Sheridan Road
Wilmette, IL 60091

Willamarie Huelskamp 76
482 11th Avenue
Salt Lake City, UT 84103

Astrid E. Johnson 44
14423 West Ravenswood
Drive
Sun City West, AZ 85375

Bev Jozwiak 29
315 West 23rd Street
Vancouver, WA 98660

Joyce H. Kamikura 22
6651 Whiteoak Drive,
Richmond, B.C., Canada,
V7E 4Z7

Howard Kaye 71
Route 8, Box 1
Lincoln, NE 68526

J. Mark Kohler 14
603 West 13th, Suite 1A-164
Austin, TX 78701

Margaret Graham 132
Kranking
3504 Taylor Street
Chevy Chase, MD 20815

Mary Kay Krell 90
4001 Ashley Court
Colleyville, TX 76034

Lynne Kroll 125
3971 Northwest 101 Drive
Coral Springs, FL 33065

Chris Krupinski 46
10602 Barn Swallow Court
Fairfax, VA 22032

Andrew R. Kusmin 8
Box 4036, 20 Boston Road
Westford, MA 01886

Janet Laird-Lagassee 70
43 Elmwood Road
Auburn, ME 04210

Hal Lambert 92
32071 Pacific Coast Highway
Laguna Beach, CA 92651

Margaret Laurie 85
4 Blake Court
Gloucester, MA 01930-3204

Alexis Lavine 27
8 Greene Street
Cumberland, MD 21502

David T. Lee 133
186 Hickory Street
Westwood, NJ 07675

Misha Lenn 116
1638 Commonwealth Avenue,
Suite 24
Boston, MA 02135

Ron Lent 132
359 Rosemont-Ringoes
Road
Stockton, NJ 08995

Guy F. Lipscomb 20
1717 W. Buchanan Drive
Columbia, SC 29206

Gregory Litinsky 30
253 West 91st Street, 4C
New York, NY 10024

Sherry Loehr 39
1365 Shippee Lane
Ojai, CA 93023

Mathilde Lombard 57
2824 Ceilhunt Avenue
Los Angeles, CA 90064

Diane Lounsberry- 86
Williams
916 Shenandoah Drive
Papillion, NE 68046

Robert Lovett 90
19 Chauvel Court
Currumbin, Queensland 4223
Australia

David Maddern 134
6492 South West 22nd Street
Miami, FL 33155-1945

Joe Manning 136
5745 Pine Terrace
Plantation, FL 33317-1326

Margaret C. Manter 6
1328 State Street
Veazie, ME 04401

Lillian Marlatt 56
15981 South West 284th
Street
Homestead, FL 33033

Lena R. Massara 42
3 Leeward Court
Salem, SC 29676

Anne Adams Robertson 70
Massie
3204 Rivermont Avenue
Lynchburg, VA 24503

Karen Mathis 32
9400 Turnberry Drive
Potomac, MD 20854

Marge McClure 65
840 Tiger Tail Road
Vista, CA 92084

Paul W. McCormack 105
P.O. Box 537
Glenham, NY 12527

Marron F. McDowell 68
2331 Caddie Court
Oceanside, CA 92056

Alex McKibbin 16
3726 Pamajera Drive
Oxford, OH 45056

Fred L. Messersmith 130
726 North Boston Avenue
Deland, FL 32724

Morris Meyer 19
8636 Gavinton Court
Dublin, OH 43017

Anita Meynig 37
6335 Brookshire Drive
Dallas, TX 75230-4017

Patrick D. Milbourn 87
327 West 22nd Street
New York, NY 10011

Barbara Millican 116
5709 Wessex
Fort Worth, TX 76133-2824

Ann Mitchell 73
28142 Sunset Drive
Bonita Springs, FL 34134

Dean Mitchell 101
11918 England
Overland Park, KS 66213

Sybil I. Moschetti 127
1024 11th Street
Boulder, CO 80302

Donald A. Mosher 113
13 Main Street
Rockport, MA 01966

Helen Needles 59
5539 Stokeswood Court
Cincinnati, OH 45238

Mary Field Neville 54
307 Brandywine Drive
Old Hickory, TN 37138-2105

Ruth Newquist 122
6 Phyllis Lane
Newtown, CT 06470

Tom Nicholas 100
7 Wildon Heights
Rockport, MA 01966

Kuo Yen Ng 78
4514 Hollyridge Drive
San Antonio, TX 78228-1819

June Parks 48
5417 Harrisburg Georgesville
Road
Grove City, OH 43123

Gloria Paterson 126
9090 Barnstaple Lane
Jacksonville, FL 32257-5077

Marietta Petrini 67
5101 Valjean
Encino, CA 91316

Santo Pezzutti 131
50 Conover Lane
Red Bank, NJ 07701

Christine A. Pitman 135
23 Bayridge Lane
Rockport, MA 01966

Carlton Plummer 124
10 Monument Hill Road
Chelmsford, MA 01824

Alex Powers 24
401 72nd Avenue North,
Apt. 1
Myrtle Beach, SC
29572-3814

Elizabeth Pratt 128
P.O. Box 238, 180 Mill Road
Eastham, MA 02642

Cathy Quiel 76
494 Stanford Place
Santa Barbara, CA 93111

Herb Rather 83
Route 1, Box 89
Lampasas, TX 76550

Jay Rather 58
Route 1, Box 89
Lampasas, TX 76550

Jerry Rose 112
700 Southwest 31st Street
Palm City, FL 34990

Jada Rowland 58
438 West 116th Street, #73
New York, NY 10027

Jeanne A. Ruchti 130
4639 Meadowlark Street
Cottage Grove, WI 53527

Giffin Russell 134
36 West Street
Antrim, NH 03440

Sandra Saitto 46
61 Carmel Lane
Feeding Hills, MA 01030

J. Elizabeth Santone 112
2985 West Burnside Road
Portland, OR 97210

Betty Carmell Savenor 18
4305 Highland Oaks Circle
Sarasota, FL 34235

Nicholas Scalise 88
59 Susan Lane
Meriden, CT 06450

Betty Lou Schlemm 141
11 Caleb's Lane
Rockport, MA 01966

Roger Scholbrock 50
115 North Main Street
Potosi, WI 53820

Babs Scott 81
2525 Laguna Drive
Fort Lauderdale, FL 33316

C. Patricia Scott 119
743 24th Square
Vero Beach, FL 32962

Barbara Scullin 120
128 Paulison Avenue
Ridgefield Park, NJ 07660

Marie Shell 53
724 Nature's Hammock Road
West
Jacksonville, FL 32259

Leona Sherwood 21
615 Buttonwood Drive
Longboat Key, FL 34228

Moris Shubin 18
313 North 12th Street
Montebello, CA 90640

Suk Shuglie 28
14 Quarry Drive
Millersville, PA 17551

Edwin C. Shuttleworth 40, 48
3216 Chapel Hill Boulevard
Boynton Beach, FL 33435

Ruth Sklar 106
14569 Benefit Street, #106
Sherman Oaks, CA 91403

Jess Slater 26
42 Pomeroy Meadow Road
Southampton, MA 01073

Dorla Dean Slider 32
268 Estate Road
Boyertown, PA 19512

Susanna Spann 96
1729 8th Avenue West
Bradenton, FL 34205

Floyd Speck 108
234 Sampson Avenue
Dyersburg, TN 38024

Barbara A. St. Denis 34
196 Doberman Trail
Easley, SC 29640

Shirley Sterling 82
4011 Manorfield Drive
Seabrook, TX 77586

David L. Stickel 89
1201 Hatch Road
Chapel Hill, NC 27516

Donald Stoltenberg 36
947 Satucket Road
Brewster, MA 02631

Charles I. Stratmann 138
5084 Atlantic View
Saint Augustine, FL
32084-7140

Shirley Zampelli 51
Sturtz-Davis
265 Newville Road
Shippensburg, PA 17257

Marion Swierkos 138
110 Fisher Road
Rochester, NY 14624

Marilyn Swift 92
20 Highland Street
Gloucester, MA 01930

Paula Temple 97
12 County Road 411
Oxford, MI 38655

Janis Theodore 94
5 Harbor Road
Gloucester, MA 01930

Debbie Tintle 110
P.O. Box 53
Chester, NJ 07930

Linda Tompkin 54
4780 Medina Road
Copley, OH 44321-1141

Lois Salmon Toole 114
561 North Street
Chagrin Falls, OH 44022

Nedra Tornay 43
2131 Salt Air Drive
Santa Ana, CA 92705

Sharon Towle 79
2417 John Street
Manhattan Beach, CA 90266

Susan Webb Tregay 7
470 Berryman Drive
Snyder, NY 14226

Pat Truzzi 107
5010 Willis Road
Grass Lake, MI 49240

Mae A. Van Ark 118
63 East 27th Street
Holland, MI 49423

Anne Van Blarcom 109
Kurowski
16 First Street
Edison, NJ 08837

Wolodimira Vera Wasiezko 69
5 Young's Drive
Flemington, NJ 08822

Louise Waters 102
720 New Warrington Road
Pensacola, FL 32506

Eileen Monaghan 35
Whitaker
1579 Alta La Jolla Drive
La Jolla, CA 92037

Michael Whittlesea 111
Richmond Cottage, High
Street, Hurley
Berkshire, SL6 5LT, Great
Britain, U.K.

Terry Wickart 120
3929 65th Street
Holland, MI 49423

Eric Wiegardt 110
P.O. Box 1114
Ocean Park, WA 98640

Mary Wilbanks 45
18307 Champion Forest
Drive
Spring, TX 77379

Marjean Willett 104
4141 North Henderson
Road, #701
Arlington, VA 22203

Edward L. Willimon 41
111 South Royal Oak Drive
Duncanville, TX 75116-4227

Douglas Wiltraut 128
969 Catasauqua Road
Whitehall, PA 18052

Ruth F. Wynn 8
30 Oakledge Road
Waltham, MA 02452

Rhoda Yanow 9
12 Korwell Circle
West Orange, NJ 07052

Donna Zagotta 115
7147 Winding Trail
Brighton, MI 48116

Joseph Zbukvic 25
1 Bundara Street, NTH
Fitzpoy 3068
Australia

Mariya K. Zvonkovich 129
1360 Montezuma Road
Colorado Springs, CO 80920